Painting

Gordon Johnston

Macdonald Educational

Made and printed by
Waterlow (Dunstable) Limited

ISBN 0 356 06007 1

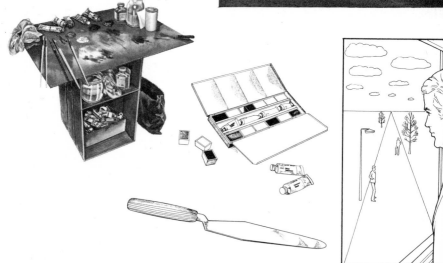

Contents

Information

Activities

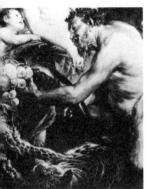

Reference

First published 1976
Macdonald Educational Ltd.
Holywell House, Worship Street
London EC2A 2EN

What is a painting?

To begin painting is very easy. It's simple—some colouring matter is spread across a flat surface and it dries leaving some kind of coloured image. By comparison with pottery for instance, where clay undergoes several elaborate processes before the object being made begins to feel like a pot at all, painting is direct and straightforward.

Yet the beginner in painting often feels at a loss. There are tubes of colour from which the paint can be squeezed out, but not in itself representing or expressing anything. Paint is so fluid that the possibilities seem endless and the skill required to achieve even a competent effort may seem vast.

Looking at paintings in galleries and museums may add to the sense of dismay. Why are there such different types of painting? Many artists have spent labour and skill on works which vary enormously. Presumably not all of them were failing in what they were trying to do—so they must have had very different intentions. But what were these intentions?

The person coming to painting nowadays is likely to suffer, not from too few ideas but from too many. However, the painting of the past is not as confusing and difficult to understand as it may look, and the problems of painting for yourself are often not as great as they seem.

Whilst some knowledge of painting which demonstrate great skill and complexity can be helpful, you would be wise not to compare yourself directly with these works. It will be far more rewarding to concentrate on what you are interested in doing. You may well achieve the very positive element of simplicity which is fundamental to many of the finest paintings.

Painting on pottery

When the beginner makes a pot, he is firstly concerned with its usefulness and if it fits its purpose. Having painted some decoration on it, an animal for instance, the beginner can accept that the image does not have to be realistic or anatomically accurate. He will be pleased if the shapes and colour are clear and lively and the overall effect is to his liking.

The same standards apply when he looks at pottery from other periods, providing the pot looks well made, well-shaped and the decoration is pleasing.

◀ Dish by William Bird, c. 1751. A man, a rose and a tulip, clearly energetically and simply depicted.

▶ A detail from the colourful, radiant and richly textured vision of the "Blessed", from a fresco of "The Judgement of the World" by Fra Angelico (1387–1455).

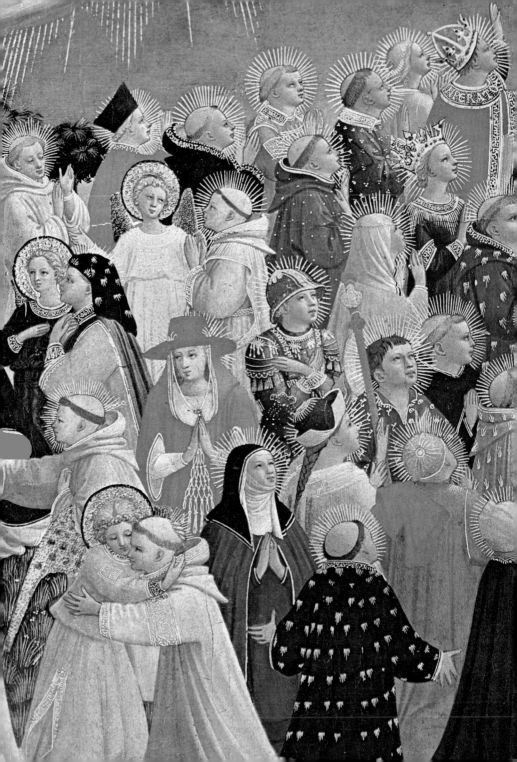

More than decoration

Painting is obviously very different, in that it does not have a strictly utilitarian function and although decoration of a room or a building is certainly a function of painting, its other attributes are generally considered to be more important. A painting might be more intensely evocative than the word "decoration" suggests. It might be an object for meditation, or include such extremes of expressiveness that it can no longer be called "decoration" at all.

Whereas painted forms are only one aspect of pottery and not even essential, the beginner in painting will probably attempt to depict space and solid forms and will want those to carry some conviction. But "accuracy" is no essential part of all this. Though some painters will echo the world we see far more thoroughly than others, always it is the vigour and liveliness of the painting that matters.

If what you do is pleasing or lively, it will be good and it will also be expressing something. If a painting gives us an experience, through its shape, colour and use of images, and it also expresses something, we shall have a rough working definition of painting.

Other definitions

If we were to think of painting as simply a way of copying what we see, we should find that many things were impossible to paint. We might want to paint sunlight on a cloud or a river and find that our mixture of white and yellow ochre, or whatever colours we tried seemed hopelessly dull and dark by comparison. We might see subtleties of colour in a face which are quite unlike any of the colours we have in paint tubes or any of the mixtures we can make.

It is true that most painters of any cen-tury, including our own, used some kind of representation or illustration of the reality we see, including space and distance. But the painters have *used* it, they have not been restricted by it. A good artist knows that he or she is using paint, not the real sun or real flesh or real grass, and that adjustments have to be made in the way things are painted to *suggest* aspects of reality. All artists adjust, balance and invent.

▼ "Charity" by Lucas Cranach the Elder (1472–1553), an artist who painted the same image of a woman repeatedly, like Leonardo da Vinci or Pieter de Hooch. Cranach's vision is sensual, with every shape and contour vividly individual and expressive.

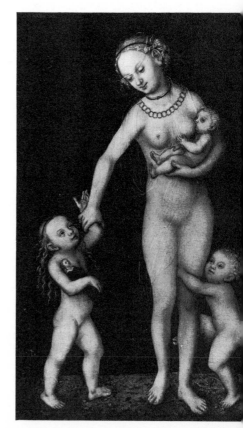

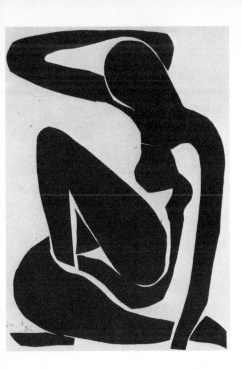

▲ "Nu Bleu 1952", by Henri Matisse (1869–1954) who emerged out of 19th century painting yet became one of the heroic figures of the 20th. His reputation is higher now than ever. His distortions are not Expressionist or neurotic, but wonderfully expressive of movement and of delight.

Another unsatisfactory definition of painting is that painting must express something in the way that words do; a painting should have a meaning that can be expressed in words. It can be reassuring to be able to label something firmly and for this reason a painting may be worrying if the elements it uses cannot be described in words.

But how can words express the essential difference between bright yellow and bright blue, which both have quite distinct effects on us? Different combinations of colours, shapes and effects of darkness or light make us respond in different ways.

There are visual effects of rhythm, obtained by repetition of the same or similar shapes or colours or forms; there is a sense of movement which can be suggested visually in many ways. Such effects have been used in art for thousands of years. One rhythmic effect might be joyous, another sad. One effect of light and shade might be mysterious, another dramatic. This is experience given to us by visual means and there are no equivalents in words.

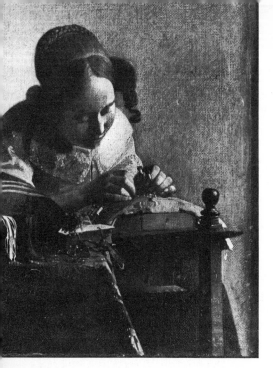

Prevailing myths

Picasso has for much of the first half of this century represented "modernism" in the eyes of those who are not in sympathy with it. He has used extremes of distortion in the treatment of the human figure sometimes for effects of tragedy and terror, sometimes for effects of movement and joyousness; but sometimes also as energetic construction. These effects have been used by other artists, but Picasso has often served as a convenient target for abuse.

The myths that surround artists should be looked at warily, because though they may serve some useful purpose, they may also be seriously misleading, and much less interesting than a more careful understanding. The myth that the painting of the past was concerned to be realistic but failed in varying degrees, or the myth that the art of this century is concerned to. be totally unreal and even ostentatious, are equally absurd.

If we look at these two paintings we see that the 17th century artist has used a meticulous and controlled technique, in which the simplifications and tiny transformations of reality are not noticed, because they are so beautifully integrated into a serene and convincing vision. The 20th century artist is here represented by a work in an altogether hastier and looser technique, with transformations of reality blatantly obvious. On one level we may regret this contrast, but if we begin to understand many works by Picasso, his enormous range of ability and imagination become evident.

Vermeer and Picasso

The paintings here show a contrast between works by two great artists of different centuries. Vermeer lived a quiet and not very long life. Less than 40 of his paintings are known to have survived, and the best of these are miracles of delicately controlled lighting, gentle movement from tone to tone, with an originality and completeness which only gradually reveals itself.

Picasso's greatness is of a totally different kind. Over a long and much-publicised life, he produced thousands of paintings, besides sculptures and many other works. Actually, Picasso deeply admired Vermeer, but even in the smallest and quietest of his works, Picasso would never imitate Vermeer; the same rapidity and fierce energy of forms is to be found in all of his paintings.

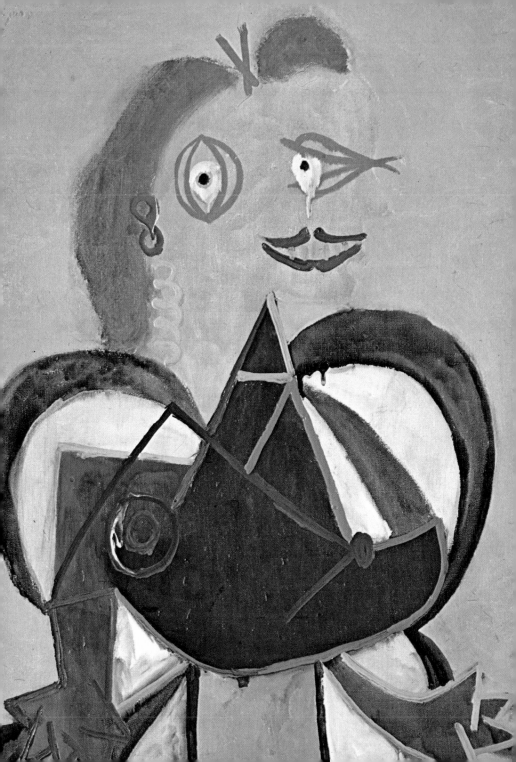

Paint and surfaces

Paint is made, firstly, from pigment, which is colouring matter. Pigments are mostly made from natural earths, or from metals, and you would normally buy pure pigment in the form of powder.

If you mixed pure pigment with water and tried to use it as paint, when the water dried out the pigment would fall off, having become a powder again.

A second "binding" medium is needed to grip the particles of pigment and stick them to an appropriate surface.

A third ingredient is usually added to the medium, to give the artist the consistency he wants; to make it thin so that it can be brushed on easily for example.

The medium used has an effect on the kind of painting which results, so an awareness of the different mediums is useful when you start to look at paintings. If you go to any large gallery, you will find paintings in pigment mixed with egg (often called tempera paintings nowadays, though the word originally referred to whatever the pigment was "tempered" with, as in "egg tempera", "oil tempera" etc.), or pigments mixed with oil, or with an egg-oil emulsion, and painted on wood, canvas, or even metal. A pigment mixed with gum produces a water-colour, or, in a dry form, a pastel, usually executed on paper. There are still other mediums. Frescoes, for example, use no "binder" apart from the wall on which the fresco is painted. With frescoes, pigment is applied to plaster while the plaster is still wet, and when it dries, the plaster itself grips the pigment.

Egg painting

Egg is a very old medium for painting and takes several forms. There was a tradition of white-of-egg painting in manuscripts, for example. Most commonly, however, the yolk has been used and the paint has been applied onto a plastery material called gesso, coated onto a wooden panel, often of poplar or mahogany.

◄ This detail from "A Mythological Subject" by Piero di Cosimo (1462–1521) is intended to illustrate the "hatching" brushstrokes used traditionally in the tempera technique.

An egg painting is generally much more detailed and exact than a fresco. Egg paint is a beautiful and permanent medium with a wide range of tone. It can be powerful in very dark effects and still be powerful in very light and pale effects, such as those used by Fra Angelico. Egg paint is still used by some artists but it is uncommon. Like any medium it has disadvantages. It is normally applied with a small brush in little strokes and the strokes dry in a few seconds (though they may take months or years to become rock hard). It is not a very fluid or changeable medium, nor has it a thick, glossy presence of its own. Oil paint has these qualities and has largely superseded egg tempera.

Oil paint

It had been known for centuries that certain oils dried to a hard film, but only from the early Flemish and Italian Renaissance onwards was oil used in serious painting. To begin with, the oil was used merely as a modification of the tempera technique.

Heavy wooden panels coated with gesso would still be used, and the painting was often built up initially with egg paint. Later, however, the painter would add a drying oil such as walnut or linseed, probably dropping it into egg and mixing them together so as to form an emulsion. In this way, the final layers of paint would acquire a more blended, glossily translucent quality.

Later, pigment was ground only with oil. As artists explored the greater flexibility of the paint film and used thicker and more immediate touches of paint, they began to use canvas instead of wood as a surface. Canvas is lighter and more convenient, especially for large-scale works,

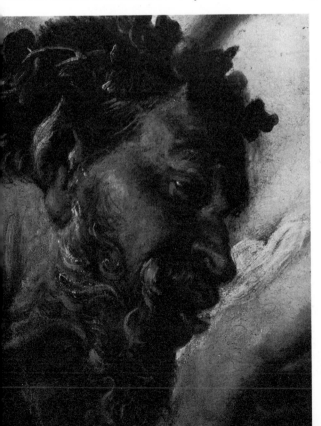

◀ A detail from "Peace and War" by the Flemish artist Peter Paul Rubens (1577–1640). Thousands of paintings bear the name Rubens, but many of these are in varying degrees the work of assistants and apprentices. Paintings purely by Rubens show prodigious abilities at subtleties of flesh-colouring, sumptuousness of textures, and virtuosity in the handling of paint. Himself heavily influenced by such earlier artists as Titian, Rubens' own influence was to reach to the 19th century, to Delacroix, and his landscapes would have influenced Constable.

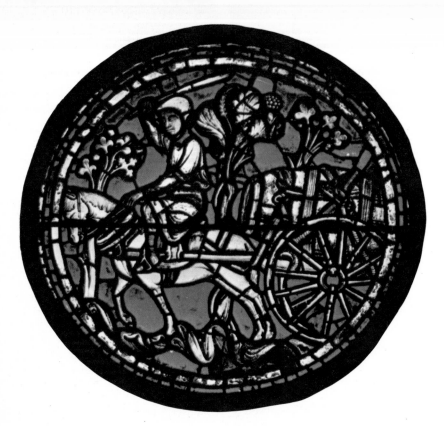

▲ "St. Lubin and the Wine Cart" c. 13th century—from a stained glass window in Chartres Cathedral. In the greatest stained glass, small areas of glowing colour build up the image as in a mosaic.

and the grain or "tooth" of the canvas takes touches of paint in a sympathetic way.

Of course, individual artists might always follow an independent line, using an older technique, but the broad effect was to make painting more direct. An artist like Rubens would use perhaps two layers of paint only, a rapid underpainting and a subtly varied surface coat which would become thin in places so that the underpainting could modify the colour. This led to the gentle shadows on the flesh of Rubens' figures. In later centuries, when painters used still more direct methods, Rubens' subtlety remained unequalled. As the illustration shows, he was also capable of astonishing vigour in his handling of paint.

Water-colour and pastel

Water-colour is pigment mixed with a gum such as gum arabic, thinned with water, and normally used on paper. It is an old and beautiful medium, though it is more restricting than tempera or oil. It can give a light, vibrant, atmospheric effect but does not easily suggest heavy, physical effects.

Pastel is pigment made into a stick by the use of a minimum of gum, and is normally used on paper. It is rather dry and chalky,

and the problem of "fixing" the pastel onto the paper permanently has perhaps never been satisfactorily solved. But fine pastels remain, from the 18th century for example, and their colours are very pure and clear by comparison with oil paintings, which tend to darken and yellow a little with age.

Mediums can be used in personal ways. Though water-colour and pastel are normally applied to paper, the modern artist Paul Klee has, for example, used pastel on cotton and other materials, and water-colour on gesso.

Mosaic, glass, tapestry

A mosaic is a picture built up with small coloured stones or *tesserae*, set into the surface layer of a wall. Stained glass and tapestry are also beautiful mosaic-like mediums, in the sense that images are built up out of small elements.

From the practical point of view these mediums lie outside the scope of this book, but studying them can be very instructive and stimulating for a painter.

For one thing, the colours are often fascinating. Stained glass uses the light outside a building forcing its way through the glass and radiating coloured light. (In early glass, the reds, or "rubies" get their extraordinary beauty from being, in fact, many layers of coloured glass fused together like plywood.) This has a relevance to painting which may not be realised.

In a marvellously glowing early Flemish painting, a translucent red or blue painted onto a white ground is also radiating coloured light at us. Light has passed through the paint to be reflected off the white ground and out through the paint again. Opaque painting can never have *that* kind of brightness.

In any work which uses small patches or areas of colour there is another factor of importance in the creating of subtlety and radiance of colour: the use of similar colours clustering together to form a powerful harmony, just as a powerful effect in music might be made by the harmony between notes.

There is more to be learnt from these mediums. The images in a great tapestry or window are beautifully transposed to the shapes and colours appropriate to the medium. Moreover, in a work built up out of small elements, our eyes and mind are led through and around the picture. This quality of "leading our eyes" is used again

and again in painting.

Looking from a tapestry to a painting can reveal these affinities. This painting of "St Jerome in a Rocky Landscape", probably by the Flemish artist Joachim Patenier, is a good example. The work is built up out of little patches of colour, or little areas of light standing out against dark, and dark standing out against light, and the small elements lead us across the surface and around a space which begins to seem vast. The original is executed in translucent paint, which will not be apparent in this black and white photograph. But being in black and white, the photograph brings out another aspect of painting; forms interacting with each other. This is a small painting but with fine detailed work—look at the figure climbing the steps, for example. It is set against such massive rock forms, and such radiance of rich quiet blues and bluish greys, that most people remembering the painting would remember it as larger than it is.

▼ This is a detail of "St. Jerome in a Rocky Landscape", probably by the early Flemish artist Joachim Patenier (active 1515, died not later than 1524).

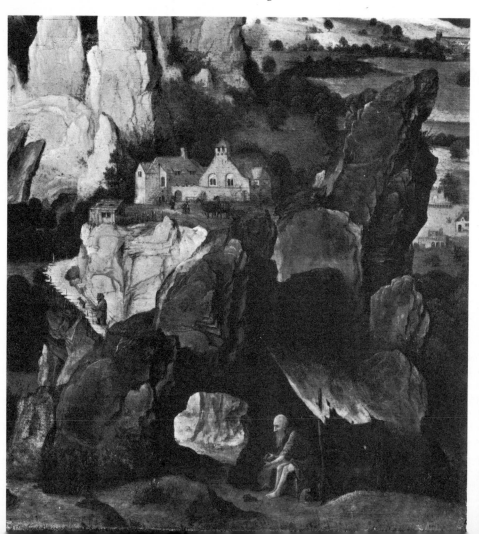

Two contrasted paintings

Two very different paintings are reproduced on the two following pages. One is an icon from the Byzantine Museum in Athens. It was painted in the 14th century and represents a great and powerful heavenly being, the Archangel Michael. The other shows a simple worker in a field, an ordinary man doing a down-to-earth job. It was painted in 1889 by the Dutch artist Vincent Van Gogh and is now in the Van Gogh Museum in Amsterdam. Both are extraordinarily rich and beautiful works.

The icon is probably painted in pigment ground with egg. It is on a wooden panel, with gold-leaf added for the background and for the highlights on the drapery. The colours are basically a warm gold-yellow-brown-red group, with cool green and bluish tints added for contrast.

Each shape has its own character. The circle of the globe (which could be taken as representing the universe), the circle of the halo, and the near-circle of the hair. Around them are springy curves. The long straight line of the staff offers the most contrast to the curves of the painting.

Van Gogh's painting is in oil on canvas, and very small. There is no red in the painting, apart from a few pinkish touches, and the whole painting centres around a mass of blue surrounded by yellow and yellow-green. The strong walking movement of the legs, the striking sweep of the back and arms, and the rhythmic, nervous twisting of the blue clothing, give the figure terrific force. Crackling brushstrokes, always with direction and rhythm, surge across the whole surface of this small and densely worked painting. But concentrated energy in drawing is reserved for the central shape of the figure.

The nature of tradition

The icon painter, however original, was working in a strong tradition, a tradition of continuity in which one generation of artists imitated the previous generation and so on. But change is also part of a tradition. Even though the artist repeats what has been done before, he is a different person in a different time, and change will occur. It is seldom realised that modern artists also work in a tradition, for it is less easy to recognise the tradition today.

Van Gogh was supported almost entirely by his brother Theo, to whom he wrote his famous letters, and to whom he entrusted his paintings. Theo's flat was crammed with them. Paintings now treasured by museums were stuffed under the bed or on top of the wardrobe. The events leading to Van Gogh's suicide include Gauguin's leaving the South of France. This must have seemed to Van Gogh, eager for companionship, like rejection from a respected brother-artist. Then came Theo's marriage—which must have set him worrying whether Theo could continue to support him—and then the birth of Theo's child. Vincent shot himself, and Theo died soon afterwards.

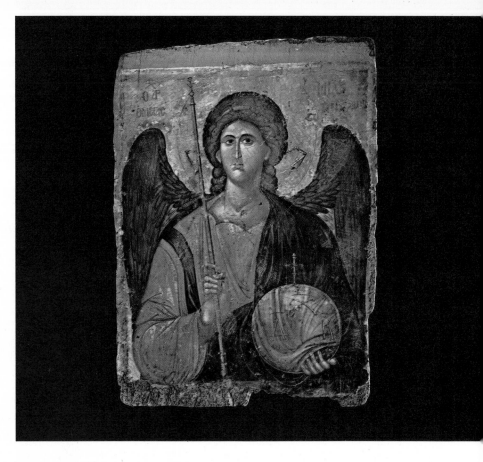

Van Gogh, with all his caring for ordinary people was deeply affected by earlier masters including Rembrandt and Millet. The painting shown was in fact suggested by a work by Millet. Van Gogh had been influenced by the Impressionists too, in his caring for sunlight and bright colours. But he forged his own contribution to tradition.

Being influenced is not a sign of weakness. On the contrary, it is the most powerful and original artists who can accept the most vigorous influences and assimilate them. Being affected by the achievements of others is no problem unless the painter is not strong enough to digest the influences and make them fully part of himself.

▲ A large and magnificent icon representing the Archangel Michael.

Painting as experience

I suggested earlier that a painting should give us an experience through shape, colour and use of images, and that though it is a kind of pattern it goes far beyond a pattern in the experience it gives us. These two paintings are intended to be clear examples of this.

Artists of any period are concerned with the problems of depicting the real world and also with patterns of shape and colour. Possibly they will try to hold some kind of balance when putting on paint, thinking a

he same time of the image and of the pattern being created; after all, these two sides of painting interlock and fuse with each other. But at each moment, each touch of the brush to board or canvas, the balance may be lost, realism may come uppermost, and the work will begin to lack the energy natural to painting. Alternatively the pattern may come uppermost, with the risk of empty decorativeness.

▼ Van Gogh (1853-1890) was influenced by many artists; in his earlier years by the English illustrators, Rembrandt, Frans Hals and many others, and later by Pissarro and the Impressionists, and Gauguin. This painting, "The Reaper", shows the influence of his lifelong enthusiasm for the work of Millet.

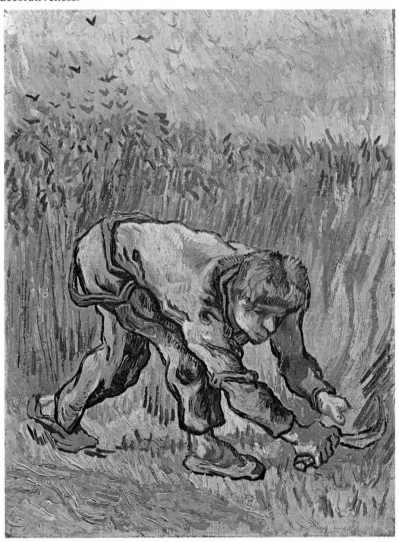

Realism

The beginner in painting is often worried by the question of realism : whether "realism" or "accuracy" is a necessary thing for a painting to have, or for a beginner to learn about. The beginner may understand very well that many artists, in many periods of art, have been attempting something quite different from realism ; but may feel— quite rightly—that realism must not therefore be passed over lightly. On the contrary, a searching realism has been fundamental to the works of many artists, including some of the greatest.

The word "realism" can mean different things. It has been used as a rallying-cry, when artists have felt that the art of their particular day has become over-refined and must be cleansed of artificiality. Or we can speak of "realism" in the case of artists who love some aspect of the way the visible world presents itself to us, and probe endlessly into the problems of transposing that aspect of the world into painting.

Cézanne

Cézanne looked long and hard at his subject, his motif, and painted gradually and thoughtfully, selecting and constructing from what he saw.

His paintings were slow to make, and they are slow in revealing themselves to the observer. He loved the great painters of the past, and was also an innovator. He wanted to achieve in his paintings the firm construction of the Old Masters he admired and reconcile that careful putting-together of parts with the difficult and confusing activity of looking at the scene in front of him and making a painting of it.

Cézanne respected what he saw and would take no casual liberties with it; he knew that the fitting-together of the energies of shape and the energies of colour must also be respected. He would keep a sense of a particular place and a particular light and atmosphere, but resolve these

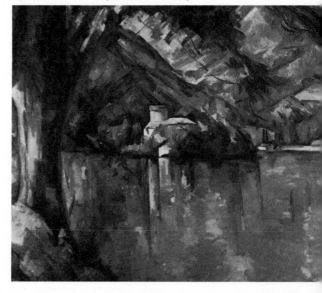

▶ "The Lake at Annecy", a painting by Paul Cézanne (1839-1906). Cézanne cared passionately both for the careful construction of a painting and for the scene in front of him. He would simply bring out certain details rather than others, and he would always resolve what he saw into patches of energetic colour.

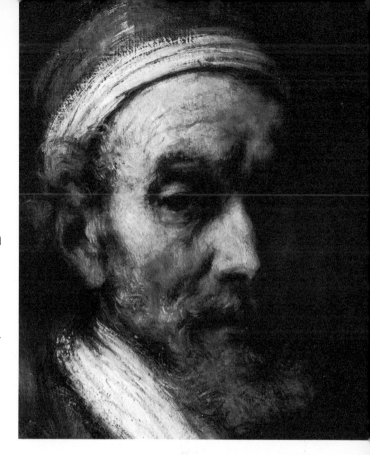

► This is a detail from the "Portrait of Jacob Trip" by Rembrandt (1606-1669). Rembrandt painted many portraits and also produced group portraits, such as the early "Night Watch". This was a tremendous piece of virtuosity in its handling of lights and shadows. The later "Syndics of the Cloth-makers' Guild" is a profound and searching study of a group of officials. Rem-brandt also painted marvellous illustrations to the Bible, such as the "Prodigal Son" and pro-duced tremendous etchings. He collected both Western and Eastern works of art.

into a mosaic of deliberate touches of paint that would build up a deeply satisfying unity.

Rembrandt

Rembrandt's portraits are beyond words. Their realism is astonishing, not because of minute detail, but because of the sense of a mass of bone and flesh which is yet con-vincing as being the picture of a particular human being. This immediacy is probably what draws people first to Rembrandt. But even when considered as paint, these paintings are still fascinating. Thinly-painted dark areas seem full of space. Trans-lucent films of paint on one part of the face blend with piled-up opaque paint on another. The shapes in these paintings again and again prove to be surprisingly distinct, powerful and wrought-out with nothing flimsy about them. Also the edges are extremely subtle—the contours of a face merge in the darkness, crisp and sharp at one point, then hardly discernible. All this fuses together in a uniquely convincing image.

Rembrandt, like most painters of his time, would not paint on a white ground. He used oil, in several layers, probably on a canvas with a brown or sandy-coloured priming. For a painter who needs to control lights and darks very exactly, to begin painting on a canvas which is already a

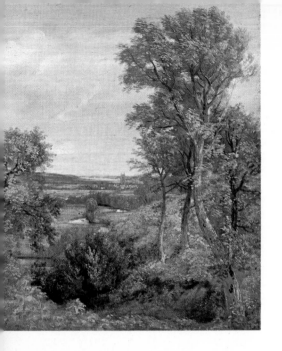

Constable

Painting directly onto a white ground begins with Impressionism; it might be reasonable to say that it begins with the attempt to paint sunlight. We should look first at Constable, the English landscape artist and forerunner of the French Impressionists, who became familiar with his work partly because "The Haywain" was exhibited in Paris.

Constable was one of the heroes of outdoor painting, perhaps the first. He was rebelling against the prettiness and artificiality that he found in much of the painting of his period. Constable's "realism" represented a powerful urge to extend the atmospheric painting that had been done up to this time; the quiet subtleties of colour and tone that build up an atmosphere of light in the works of the earlier painters he admired such as Claude Lorrain, Rubens, Watteau, Ruisdael, Gainsborough, all great painters of landscape. To extend this atmosphere Constable went out and painted the landscape directly, wrestling with colours in front of nature.

Yet he was less extreme than the later painters. For one thing, the paintings done from nature he regarded as sketches for more carefully finished paintings to be done in the studio. For another, he would paint on a brown surface rather than a white, because he wanted to balance tones, carefully gradating the degrees of darkness in his painting to achieve his effects of light.

middle tone enables him to work both darker and lighter. He can then extend the range of tone until the lighter parts approach white and the darker parts approach black (pure white and pure black are rarely used except for black or white clothes).

White priming

Most students today start painting onto a white-primed canvas, but very few artists did so before the 19th century. Their panel or canvas might have had a white priming of some kind to begin with, but that would have been covered at a very early stage of the painting, possibly by a second priming which would not be white. It may seem laborious to cover a white priming with layers of darker paint so that it is hidden, but remember that oil paint gets more transparent with time, as well as darker, so that a white ground behind everything else will reflect more light with time, and help the painting to keep some luminosity.

This method has its limitations.

The lightest tone in oil paint is white, but that is dark compared with outdoor effects of bright sunlight. Consequently, "realism" is often impossible. But realism is never in itself the point of a painting.

Constable's effects of sunlight now look very quiet beside the effects of later artists. Yet his loose and varied handling of paint with its dabs and palette-knife flecks, must have surprised his contemporaries. At first the paintings must have looked very unconventional; later they seemed as realistic as any ever painted; today, Constable is an Old Master.

Is "realism" realistic?

The sequence of responses, such as the reactions to Constable's paintings, occurs again and again. What begins by surprising comes to be acceptable and "realistic". What ultimately matters is not realism, but something which is linked with the particular character and vision of each artist and his relationship to life.

If realism, in the sense of tricking our eyes, is what ultimately matters, we should have to consider all such artists as having failed.

Impressionism

Impressionism involved transposing the visible world into spots or dabs of pure colour. The fact that Impressionist works clearly were not an imitation of the world caused tremendous opposition. It must have seemed as though all the skills of draughtsmanship, knowledge of perspective and anatomy, the craft of building up

▼ "Louveciennes Road" by Camille Pissarro (1830–1903), grand old man of Impressionism, and helper of many, such as Cézanne and Van Gogh, who liked and admired him. His work is modest, restrained, and strong.

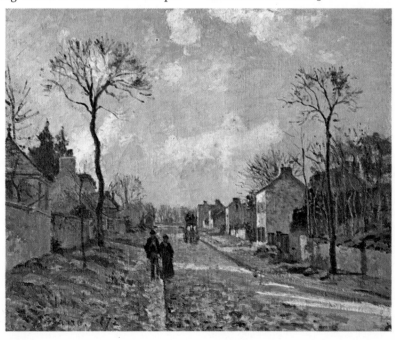

a painting and finishing it smoothly, the art of using a painting to illustrate a story or point a moral, in fact all the qualities demanded by academic critics of the 19th century, were being discarded.

Later, it was realised that the Impressionists seemed to have conquered a new world for painting. Fresh effects of sunlight and fleeting nuances of air and water, could now be realised. Subject matter too was extended; streets with people just passing by, river scenes with people fishing acquired a kind of magic which no photograph would convey.

In some of their works, the dabs of colour are so finely balanced that no reproduction could do justice to them.

▼ "A Boor Asleep", by Adriaen Brouwer (1605–1638), friend of Rubens, and maker of small paintings which, though seemingly similar to other "genre" paintings of the time, have greater sharpness and mastery.

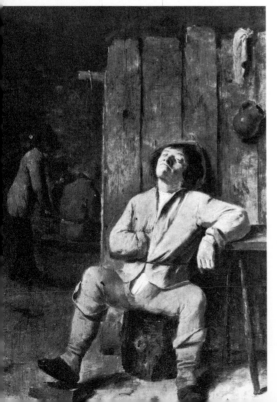

▲ Honoré Daumier (1808–1879), known in his time as a satirical cartoonist, but now admired as painter and sculptor of works that are small but have massive realism and vitality. Above is a detail from "Don Quixote and Sancho Panza".

As time moves on, our attitudes change. Some modern painting has needed such a clear image that the artists work closely from photographs. Compared to these, some Impressionists' works may seem self-conscious, with their chunks of colour. But in other kinds of modern painting it is precisely these chunks that have been developed in further areas of expressiveness.

Good Impressionist paintings remain untroubled by all this and, in a sense, realistic. Another "realistic" approach to painting involves the treatment of themes that we know and recognise. Homeliness of subject matter takes precedence over imaginings, and may require a small scale and an undemonstrative handling of paint.

Other realities

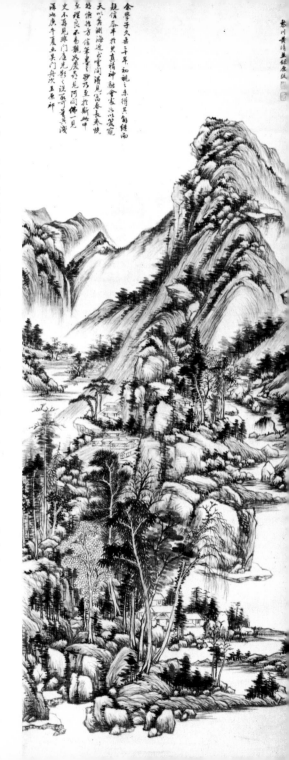

We have been looking briefly at some artists who were concerned with the visible world. Finally, in this introductory section, we should look at some of the artists who deliberately depart from what is seen because they want to express something that cannot be seen. This category of painting is a huge one. It could include all religious painting, and all that might be labelled Expressionist—painting that distorts images so as to express emotions or ideas. El Greco, for example, converted his figures into elongated, flame-like shapes to express religious ecstasy. Goya invented nightmarish figures to depict the horrors of war and greed.

Painting that simplifies and re-orders the objects of the visible world also falls within this category. It might be called Idealist. The search for perfect rather than realistic forms has engaged artists from the past such as Piero della Francesca or Poussin and present abstract painters too. Some modern abstract painters are in this sense Idealist.

Selection and simplification

Selection is always necessary in painting, because the visible world presents us with a mass of information and no painting can make use of more than a few aspects and parts of it.

▶ No single example can give an idea of the great range and intensity of Chinese painting, one of the longest and greatest traditions in art, and one from which we can still learn a great deal. The illustration shows a 19th century painting on cream silk, a copy of a Yuan dynasty painting.

For beautiful examples of thoughtful selectivity we might look into Chinese painting. This is clearly concerned with the world we see, yet it never makes the mistake of imitating it. The Chinese painters of, for example, the great Sung period, studied techniques passed from generation to generation for the appropriate brushstroke for a type of leaf or branch, or for a particular atmospheric effect. With this they fused a study of the appropriate brushstroke for a particular feeling or emotional effect. The brushstroke itself was the subject of study, and the state of mind in which the painting was made.

There is a thoroughness and completeness about this attitude to painting which Western art has sometimes lost. Words exist in Chinese, as in ancient Greek, for aspects of painting for which there are no equivalents in the modern European languages. The beginner should not feel restricted if he can find no words to describe what he is trying to do. It is better to trust intuitive judgment.

Morandi

Perhaps this point will come over more clearly if we look at some artists of our own time. Morandi is a modern artist who achieves remarkably satisfying and moving results with extremely limited means. A few jugs or bottles painted in restrained "earth" colours are slowly and thoughtfully worked to give quite evocative results. His paintings seem to describe the way that objects and, by analogy, people live together, inhabit the same place, fit together with strain or with serenity, perhaps with a precarious balance of both.

This may seem a personal interpretation, but some such thought is inevitable. Morandi spent most of his life doing again and again small still-lifes composed with everyday items, giving them not merely a

more and more finely adjusted balance, but a greater resonance and suggestiveness. He began his mature work in a rather different way, associated with de Chirico, putting together weirdly evocative images in a Surrealist manner. As he developed a purely personal style, he rejected the weirdness, but the evocative qualities remained.

The painting of ordinary images in a straightforward way, yet somehow making these images have resonance, or overtones, so that we feel that far more is being communicated to us than the obvious subject matter of the picture, is not a kind of painting that can be easily labelled. Even extremely detailed realism can give a poetic rather than a naturalistic effect.

▼ Giorgio Morandi (1890–1964) was born in Bologna and lived most of his life there, producing his calm and considered still-lifes, somewhat as the great Dutch artist Vermeer had done who lived in Delft 300 years before. This still-life, for all its quietness, is very alive.

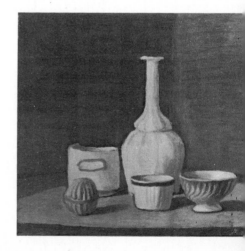

Surrealism

Many paintings of the last 100 years bring together, for no apparent reason, images of things that seem to have no connection with each other. Many painters of the past might be called Surrealist because they used an extraordinary degree of fantasy in their work. Hieronymus Bosch and William Blake conjured up startling images for a specifically religious purpose. Goya exposed the horrors of human vice and cruelty in his terrible symbolic figures. Grotesques have long been acceptable in entertainment too, particularly in comedy.

The difficulty in appreciating the modern Surrealist movement in painting, is, however, understandable. We may feel that a painting should be something we contemplate and get to know slowly, that that is

▼ Marc Chagall was born in 1887 and went to Paris as a young man. He returned to Russia to marry, and got caught up in the Revolution of 1917. Later he settled in France and continued to produce some of the finest modern paintings, etchings and ceramics. This is the "Birthday" of 1915.

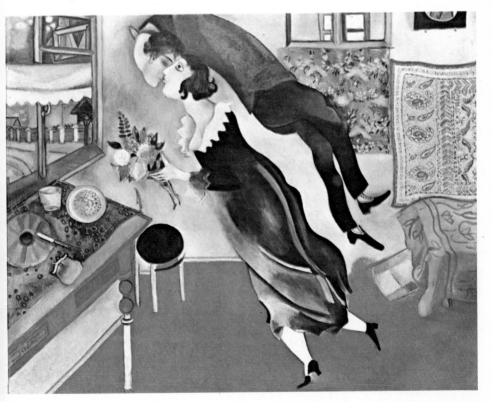

its strength, not its power to shock.

There is a difference between using a Surrealist technique in telling a story or pointing a moral, and using it for its own sake.

Chagall and de Chirico

The two immediate precursors of Surrealism were Chagall and de Chirico. They came to Paris in the early years of this century, one from Russia, one from Italy, because it was here that exciting things were happening in the arts. Like other artists, they learnt from the poets how to experiment exuberantly, and from painters like Picasso and Braque how to put together our experience of objects and space in new

▼ "Le Principe de Plaisir" by René Magritte, a Belgian artist of admirable consistency, who used a deliberately dull type of realism in which startling elements were incorporated.

ways. There has been a great deal of writing and theorising about this period, and many words ending in "-ism" have been invented. However useful such words may be, they all too easily give the impression that modern painting is split up into different camps, and that artists must belong to one or another. Although this is not the case, there was a definite movement called Surrealism which was started after World War One.

Both of the famous precursors were asked to join; Chagall refused. Chagall has said that he paints with one foot in the conscious and the other in the unconscious. The dogmatic Surrealists with their insistence on shocking people out of their complacency were not so well-balanced.

De Chirico joined them for a while, but uneasily. His enigmatic and sombre work has a poetic rather than propagandist quality. Magritte, an artist heavily influenced by de Chirico, was probably a lesser artist because his visual inventions too often degenerate into trickery. He nevertheless produced some striking images often beautifully presented. Such imagery lingers in our minds, adding something to our mental lives without our being able to say quite what.

Dreams and paint

Technically, the artists that belonged to the Surrealist movement can be divided into those who used illusion in handling startling or disturbing themes, often suggested by dreams, or the theories of psychoanalysts, and those who began with the paint itself and perhaps had no preconceived idea at all. They allowed the fluidity and malleability of paint to suggest images which emerged unexpectedly and asserted their own needs. Both techniques have continued to be used, with many variations, in the works of artists and students up to the present day.

Preparing to paint

The following sections aim to give practical advice to the beginner. They look at the basic materials used in painting, and also consider some of the technical problems which the beginner is likely to meet in painting either from what he sees, or from the imagination. Following precise instructions for making a painting would result in dull and dispiriting work. Though the beginner might avoid making a mess, he would lose the exhilaration of creation. Examples of how various artists have faced problems are useful but most satisfaction is derived from developing one's own vision.

Which kind of paint to use?

You should try any medium which you feel inclined to, and that seems appropriate for the resources available. Water-colour, for example, is the lightest to carry about and easiest to clean up afterwards. It also has a delicacy and clarity of colour. These factors may be important, but if you can choose any medium, and have no idea which to select, I suggest you begin with oil paint.

Some people may be intimidated by the thought of using oil paint because of an idea that it is technically advanced and very demanding. It is true that oil paint can get messy and difficult to handle, but with a little persistence, the problem is soon solved. Though some artists developed complex techniques in oil painting, it is also an appropriate medium for simple and direct painting. This is because it can rapidly give a full sense of colour and tone (tone is simply the lightness or darkness of a colour) and consequently a sense of the weight and presence of things.

Oil is a very flexible medium, since it can be brushed in a stiff or very liquid form, smeared and dabbed with the fingers or palette knife, applied in a chunky, opaque way or a filmy, translucent way. Many things can be mixed with it to give a consistency appropriate to the effect you want. The fact that it dries slowly is an advantage, once you get used to controlling the edges and the changes of colour, because the paint can be manipulated while still wet and easily changed.

Quality and quantity of paint to buy

The difference between artist's quality paint and other quality such as student's quality paint is important. But if you are beginning to paint, you may feel that the cheaper brands will give you some idea of the colours and will be all you need initially. Certainly interesting and satisfying work has been done with low-grade paints. It may also be enough to begin by buying very small tubes of paint.

If you get really serious about painting, however, the richer colour of artists' quality paint will begin to matter a great deal. Similarly, buying small quantities may prove inhibiting and inconvenient.

I suggest that the number of colours and the quality of the paint are the last things on which you should economise. Palette, easel, paintbox, all sorts of equipment can be improvised or omitted; the surface on which you paint can be made cheaply, even for serious work. It is unlikely, however, that you will be satisfied with cheap paints for very long.

Choice of colours

The following colours are very basic and durable. They occur in most painting mediums, so that you could buy the same selection in water-colour, for example. They are found indispensable by most artists. Of course there are many other

colours you can buy, and some you may come to prefer to the ones mentioned below. But I would suggest caution: the following colours are either totally permanent or very nearly so. Few are poisonous, and no adverse chemical effect occurs when they are mixed. Not all colours are as reliable as these.

1 Titanium white
Experts tell us that there is no ideal white oil paint. Titanium white, Flake white and Zinc white each have their advantages and disadvantages. I suggest Titanium white for its dependability. Flake white may be preferred, but remember that it is lead-based and therefore poisonous.

2 Ivory black
This is a standard black, as is Lamp black.

3 Cobalt blue
A beautiful and permanent blue which veers towards greenish, as does Cerulean, another permanent blue.

4 French ultramarine
This is a rich, almost purplish blue.

5 Viridian
A very sharp bluish-green. Mixed with a lot of white, it is very like pale blue. For landscape painting you might also come to value Terre verte, a weak but good and permanent colour which will give you the gentlest of green tints.

6 Cadmium yellow
This is among the most durable of the bright yellows, though expensive. It comes in several grades of fullness of colour, Cadmium pale, Cadmium deep, and so on.

7 Yellow ochre
This is a duller "earth" yellow. If it is good quality, it is one of the subtlest and most useful colours of all. It can look very rich, very greenish, even pinkish, depending on how it is used and what colours surround it. Mars yellow and Raw sienna are other very useful deeper yellows.

8 Cadmium red
It has the same advantages as Cadmium yellow.

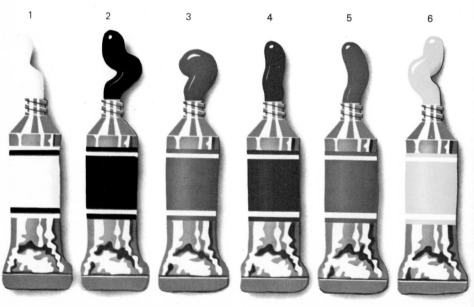

1 2 3 4 5 6

9 Alizarin crimson

Differing opinions are held as to its complete permanence, but no one can doubt its usefulness.

10 Mars red
11 Indian red

These are not bright reds, though they can be very rich when translucent. They are valuable when, for example, mixed with white to form different pinks. Indian red is colder and more blue; I suggest Indian for preference if you can get only one of these. There are other permanent "earth" reds, Light red and Burnt sienna, for example.

12 Raw umber

It is a brown of a slightly green tint. Burnt umber has a slightly more reddish tint. You could have both, but Raw umber is often found more useful.

Individual artists may prefer to work with fewer than these twelve colours, or may limit themselves to fewer for particular paintings. But if you are exploring colour and if you value its radiance and energy, twelve colours are not very many. Remember, if you mix colours they lose in brightness. Cadmium red mixed with blue will *not* give you Alizarin crimson. Get these twelve if you can, perhaps adding others as you continue painting.

Brushes

Two types of brush are most commonly used in oil painting; the stiff hog-hair or "bristle" brush, and the soft-haired type, such as the sable.

The stiff-haired brush is best if the paint is to be used straight from the tube, or with the minimum of thinning. It can be dipped into the little pile of paint on your palette and used to smear it firmly onto the canvas.

If you are painting onto a smooth surface, for example paper, card or hardboard however, the bristles of a stiff brush can make little scratches in each brush-stroke. This may not worry some painters; but others will find some kind of soft-haired brush indispensable.

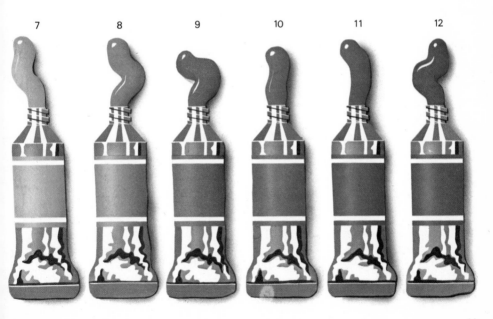

Size and shape of brush

You will not need many large brushes, but you will probably need several medium to small bristle brushes. This is less because you will want different effects from individual brushes, than because you will need one brush for each of your basic colours. Otherwise you would have to wash a single brush scrupulously each time you wanted to apply a new colour.

Flat brushes, square-ended and what are called "filbert"- shaped brushes with their layer bristles are likely to be flexible and give you variety of handling.

In addition to these bristle brushes, I suggest several small and pointed soft-haired ones if your work is likely to be detailed or require thin line-work. Flat, soft-haired brushes are

▼ Different types of brushes suitable for oil painting.

useful for smooth effects.

If you like the paint to be brushed on freely and are not concerned with smooth finishing or detail, just use bristle brushes. If you need soft-haired brushes, pay no attention to whether the art shop calls them water-colour or oil brushes, look at the hair. Sable is probably the best, and has some spring and shape to it. Though cheaper brushes may be satisfactory, they are too often limp and floppy.

There are also nylon brushes which may be found useful.

Care of brushes

It is possible to be too fussy about the quality of a brush, but a good brush should be always carefully treated and washed after use.

When oil-painting, wash the brushes frequently in turpentine or white spirit, pressing the hairs gently with rags or an absorbent material such as toilet-tissue paper. Make sure that you wash down to the metal ferrule which holds the hairs

—brushes get easily clogged at that point.

After rinsing the brushes in turpentine, you can wash

them in warm water with ordinary soap. You need not do this every time you use

the brushes, but do it fairly frequently. Simply work up a soapy lather on the palm of one hand, and gently rub the brush about it, stroking out the paint from the ferrule. The colour has been washed

away once the lather becomes white, and you can then rinse the soap out of the brush.

If you are painting on reasonably receptive surfaces and your technique does not involve stabbing or scrubbing with the brush, a good brush will last for many years as long as the precautions mentioned above are observed.

Palette

A palette is a piece of polished wood (so as not to absorb the paint) or plastic,

shaped so that it is easy to hold. The artist sets out his blobs of paint around the edges, leaving a clear space in the middle for mixing the colours. Traditionally, the artist stands at his easel holding the palette and some brushes in his non-painting hand, and mixes the colours and applies them to the canvas with his painting hand.

In practical terms, no such stance is required, and the palette itself can be improvised.

For example you can put out quite a large piece of hardboard on top of an old box or table. The board could be big enough to hold tubes of paint, rags, medium, brushes and anything else that you need, and still have space for you to squeeze out the blobs of colour and mix them.

To begin with, the hardboard would absorb the paint if left untreated, so you should wipe over the mixing-area with a turpsy rag at the end of each day. After that, the hardboard will make a good palette.

▼ Types of palette.

▲ A double-dipper.

A "dipper" is a little double can which clips onto the palette. This holds turps and perhaps another painting medium. If you are using a large board, generous-sized jam jars will hold much more.

If you are working outside rather than indoors, you may have to use a palette that you can carry easily. The smaller palette is also useful if you like moving up to your picture and back again a good deal.

Setting out paint on the palette

If you want all your colours to be available, set out a little heap of each around the edge of your palette. Put out too little rather than too much, for excess paint will spoil if it is left out for too long. Some people recommend arranging the colours with the white nearest to you, the others set out in a gradually darkening sequence, and always sticking to the same order. Of course, this is entirely up to you. You may prefer only to set out the colours you think you might need.

The important considerations concern the paint itself.

Too much mixing is probably bad from every point of view. You should also avoid leaving the caps off the paint tubes or using half-dry paint.

Clean the palette at the end of each day; the mixing area in particular, and preferably the whole surface. Piles of paint can be left for use next day, but this is a pardonable, occasional laxness rather than an ideal procedure.

Palette knife

I suggest a trowel-shaped palette knife of the type illustrated. This is useful for mixing paint, scraping it off the painting if necessary, and applying the paint occasionally. I would not recommend using several small palette knives to paint with. This technique is usually a very restricted way of handling paint, for many colours which can be rich and luminous when translucent become heavy and dull in pasty opaque layers.

In effect, using a palette knife exclusively limits your colouring. Moreover, a consistently thick layer of paint is more likely to develop cracks than a thin or uneven layer.

▼ A palette knife.

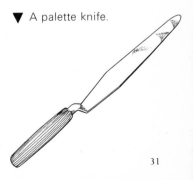

Easel

An easel is not essential. You can simply prop up your canvas, or work on it flat if it suits you. Should you want to buy an easel, the light, folding type is obviously best suited to outdoor painting, whilst the heavier kind may be more suitable for larger works done at home.

Artists using oil paint have often preferred their canvas to be held in a vertical position in front of them, or even tilted slightly forwards at the top, to prevent light from glinting on the wet paint.

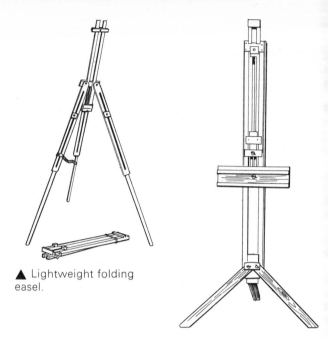

▲ Lightweight folding easel.

▲ Studio easel.

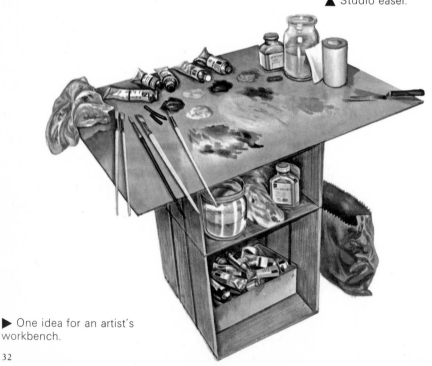

▶ One idea for an artist's workbench.

The surface you paint on

Here are some cheap and practical ways for the beginner to prepare canvas or boards for himself.

I suggest that you use hardboard, though stiff cardboard, seasoned wood, plywood or chipboard can also serve. The smooth side of hardboard is perhaps best, provided that the hard slickness of the surface is first removed by sandpapering.

The principles involved are these: the oil paint has to stick onto the surface, and can do that either by being absorbed into the surface, or by gripping a rough texture on the surface, or by a combination of both.

If the surface is absorbent, it must not be too much so, for the drying oil in the paint will then be absorbed to such a degree that the particles of paint are no longer held firmly. If the surface is not absorbent enough, a rough texture will be needed to help the paint grip.

"Size" is a transparent layer which simply makes a surface less absorbent, sealing it off from the oil paint.

Size can be bought, usually in crystal form, from art shops. The crystals are dissolved in cold water, generally in a proportion of about one part of the crystals to 12 of the water. The solution is left to soak overnight, then gently heated, and a thin coat is brushed onto the surface to be prepared. After a further 12 hours or so, a second coat is applied and left to dry.

If you are in any doubt about the strength of the size, let the crystals soak, and then, after having gently heated the solution, let it go cold again. It should form a jelly which resists pressure from a finger in a rubbery way. It should neither be weak and crumbly, nor rock hard. The jelly will melt on gentle re-heating and can then be used as before.

The layer of size on the board or canvas should not be too thick. The size is meant to soak in and make the surface less absorbent, but without forming a hard, glassy film on top of it.

Other materials can be used to seal off boards transparently, including mediums sold for use with acrylic paint. Painting could start on the sized board, but "priming" is usually applied first.

Priming

Priming is one of several coatings put on top of the size to offer a good ground for the paint. It may also provide a desirable background colour such as white.

For oil painting, an oil priming will naturally be preferred. If you have coated a board with size, you can buy a can of artist's oil primer and apply two thin layers on top of the size. These should be left to dry for as long as possible.

You can, however, use simpler means. Acrylic primer, for example, needs no size. Simply sandpaper the hardboard (plywood

and chipboard do not even need this) and apply coats as recommended by the maker. Two are generally sufficient. You will find that the first is rapidly "sucked in" by the board and the second goes on more easily.

You can also use decorators' materials to prime your surface. Emulsion paint and undercoating for gloss paint, for example, are good, but as a general rule it is best to use artists' materials. The reason is simple; decorators' paint is not intended to be "permanent" in the same way as artists' paint. A room will be re-decorated in due course, but a painting is intended to last indefinitely.

The comparative simplicity of priming should be stressed. Two or three coats of an acrylic primer, or two coats of oil primer on a sized surface should not present you with any problems. Oil paint "sinks" unpleasantly, that is, it goes dull and dead, on an over-absorbent sur-

▼ Priming a canvas.

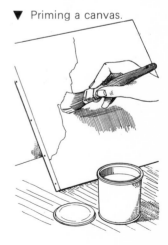

face, but these simple methods of preparing a board should ensure sufficient resilience for reasonable results.

Preparing a canvas
A small canvas can be stretched by hand, and the following suggestions are made with a small canvas in mind, which is easy to manipulate. Canvas pliers may be used to grip the canvas when stretching it, exerting much harder pressure by rocking the pliers on the curved part lying underneath the wide horizontal jaws. Such pressure may be necessary on a large heavy canvas, especially if it is already primed. But for a small, light canvas, even if primed, gripping and pulling with the finger is sufficient.

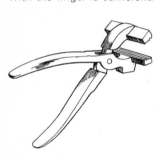

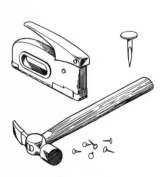

Traditionally, hammer and canvas-tacks are used but often nowadays the canvas is simply stapled to the stretcher with a staple-gun.

Fitting the stretcher together
You may have bought the stretcher in pieces, so it must be assembled, remembering that any sharp edges which have been left on the wood must not come into contact with the canvas. The stretcher-joints hold together firmly by slotting together.

Cutting canvas to size
Remember that the piece of canvas must be several inches larger at each side than the stretcher. The additional width allows not

merely a neat edge—it will have to be wide enough for your fingers to be able to grip it.

Tacking
Put first tack in the middle of one edge, then turn the canvas upside down, pull the middle taut and put second tack in middle of *that* side. Repeat process for two remaining sides. Start working outwards from each central tack, putting another tack in every 100 mm, or thereabouts, turning the canvas constantly.

Pulling vertically
Always pull vertically upwards—*not* diagonally outwards from the centre.

Corners
Two folds will be necessary at the corners, one taking up slack from one edge, the

other taking up slack from the other edge, then folding over the first fold. The loose canvas at the back should be stapled down for neatness;

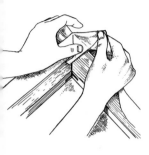

not nailed or tacked into the wood.

Wedges

When the canvas is stretched, put the wedges in lightly, tightening equally. The wedges are *not* used to stretch the canvas initially, but to be tightened and then loosened again should atmosphere changes cause temporary slackening of the canvas.

When tightening wedges, of course hammer lightly and equally. It may be advisable when stretching not to hammer the *tacks* in too

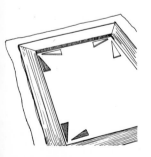

firmly to begin with, because if the stretching goes wrong you may have to take them out and start again. But once the canvas is stretched hammer them in properly.

Modifying oil paint

Thinning is done to change the character of the paint, enabling the artist to brush it on more fluidly. Turpentine is the most common medium used. It is a volatile oil (that is, it evaporates) rather than a drying oil (which forms a hard film).

Turpentine thins paint easily and should be used sparingly. If you use too much without adding a drying oil, the paint will be weakened both in appearance and in permanence.

There is a famous principle which advises "fat over lean", that is, the oilier layers of paint should be the top layers, not the bottom ones. A first layer of paint, thinned with some turpentine is quite common, then layers of paint above that used without turpentine.

I suggest that you begin painting in this way, using colours straight out of the tube with a small amount of turps to thin especially the first layers of paint.

If you want shining and translucent glazes, however, this method will not work. A common drying oil is linseed oil, but used on its own it will yellow and shrink, and wrinkle with age, so manufacturers produce "painting mediums" which aim to give a more stable

paint film.

A typical mixture might combine equal parts of linseed oil, turpentine and damar varnish. There are many variations on this blend, the brittleness but resistance to yellowing of one ingredient being combined with the elasticity but yellowing tendencies of another.

There are also ways of modifying linseed oil, perhaps the most useful being the making of stand oil from it.

The mediums that can be bought nowadays include the synthetic gel mediums ("alkyd" mediums), which dry quickly giving an eggshell finish, or a gloss finish if more is applied. These are very easy to use. For a matt finish you could use a waxbased medium. These are especially useful to prevent thick touches of paint from shrinking. Both gel and wax mediums are sold by reputable manufacturers, and I suggest that you experiment with the different brands.

Varnishing oil paintings

Varnishes are designed to protect a finished painting, and can be bought in bottles or in spray cans. The best are synthetic or based on damar. The painting should be six months to a year old before the varnish is applied, but varnishing too early is said to be better than not varnishing at all. Manufacturers do make matt varnishes, but these are not always as strong as the gloss varnishes.

Beginning a painting

The beginner may feel inhibited at the outset of the painting. There are three basic types of approach. You can paint directly from a subject, for example a person, still-life, or view. Or you can begin with a patch of colour which can then be shaped and extended, working intuitively and feeling your way, and not worrying initially whether the final result looks like anything. Or thirdly you can work entirely from imagination on a picture which need not be entirely realistic, nor entirely abstract. Trying to be too exact may destroy the experiences and insights which you might otherwise gain, so if painting directly is too painful an experience, don't attempt it.

Painting from a subject
Your subject is in front of you, no matter how simple, and you think you would like to make a painting from it. It could be a person, a place that you know, or still life, but objects that do not stretch away into the distance will be easier to begin with.

Look at your subject and try to pick out some of the individual patches of colour from which it is made. Even if they are made of glass or shiny metal, your eye will still register them as patches of colour. Try to see these patches of colour and, one at a time, find rough equivalents in paint for them and

put each down on the canvas in what seems a sensible place.

It may be that what you *know* will get in your way. You may think: it's a jug, it should stand. Though this is true, think of it first as an area of colour, even if the shape of the jug suffers or if it looks wobbly.

Although you should not be deliberately casual about its shape and solidity, attempt one thing at a time and let the colour come first.

If you are looking at an object, an orange, for example, unless it is in unusual lighting or shadow, it will be orange in colour. Orange is made up of red and yellow, so you will be mixing red

◀▶ Cézanne's "Blue Vase", a small painting (600 mm x 500 mm), predominantly blue—a blue vase standing out against a blue background —with quiet harmonies of green and contrasts of reds and yellows.

enough to bring some air back into the painting, and to allow the orange to stand out on its own. All artists adjust tones and colours continually.

It may be that the background looks wrong around the orange because much of the canvas elsewhere is still white and untouched. In this case, simply carry on putting your patches down. The painting may come together as the canvas is filled in. Building up a picture can be a slow process.

Edges

Edges often worry the beginner. The point at which two areas of different colour meet can be messy. As oil paint dries slowly, edges present a problem, yet it is one that disappears with experience.

It is not that there is a procedure to be learnt, simply that the paint becomes easier to use with practice. You will find it easier to bring one area up to another, keeping a sharp edge, as you get used to handling a paint brush. You may cease to worry about getting a minutely exact sharpness to your contours; for most painting this would be inappropriate anyway. Even having a thick, wet layer of black paint and bringing a pure, bright colour up close to it can be done, if you take particular care.

paint and yellow paint, probably Cadmiums.

The orange, however, will probably not be the same colour all over. It may be lighter in one place than in another, there might be slight tints of something other than orange. There may be a hint of blue reflected from the blue daylight outside, for example, but to put pure blue in among the orange might seem excessive.

Don't panic. Basically the thing is orange, basically its shape is round. At least you can get those qualities

down. Varying the mixture of red and yellow, using a little of a different red or a different orange may be all you need to get the picture started.

When you start painting whatever is beyond the orange or a background for it, you may find that the patches of paint you choose press so closely around the orange that your painting seems heavy and claustrophobic. Try changing the background colours, lightening or darkening them, or simply scraping some of them off. That may be

I recommend using the paint pure, adding nothing except perhaps a little turps, but keeping your layer thin all the same. A smallish brush will help, and you should mix the colours as little as possible.

Brushwork

I suggest that you use medium to small brushes for most of your work. Too small a brush can be finicky and not hold enough paint. Too large a brush can sweep about unthinkingly and prevent the slow building-up of forms.

Any painting leads the observer's eye from one part to another. The way that the artist's own eye was led and the way he built up his strokes of paint, can affect the observer powerfully. If the brush is too large and the working too rapid, the observer's response may be one of restless dissatisfaction.

The way that the eye and the mind move across a painting is a subject that leads far beyond the practical questions we are considering here.

Mixing colours

I suggested earlier that you should mix colours as little as possible. Obviously you *will* have to mix them, for how could you make a pink except by mixing red and white? If you are painting leaves and your only green is Viridian, that may be too sharp and you may have to mix in some white or yellow.

You may want to make your own green by mixing blue and yellow because Viridian is altogether wrong.

Of course you have to mix colours, and often with white. But keep your mixing to a minimum. Get to know your colours and find out what they will do for you in their natural state. Moreover, mixing many colours together normally leads to muddiness and lack of character in the colouring. It is the energy of colour in your painting that really matters, and pure colours will be the most helpful.

This applies even where your pure colours are restrained ones. Raw umber is a greenish brown, Burnt umber is a reddish brown, and the two placed next to each other will give you a restrained colour contrast. If you mix browns out of three or four colours, you will never get such clearly defined character. The same principle applies for Indian red set against Mars or Light red, especially when white is added to turn them into pinks.

Mixtures are less bright, and sometimes less permanent. Avoid violent mixing, red with green, for example, or blue with orange. Think, perhaps, in terms of *modifying* one colour by adding a little of another, rather than bringing together contrasting colours in unpredictable mixtures. Of course, these are suggestions; there are no rules that must always be kept.

▲ Detail from a painting of his water-lily pond by Claude Monet (1840–1926). Monet was the supreme Impressionist, the painter of fleeting lights and shadows, reflections, smoke, atmosphere. He would have many canvasses under way of the same subject, and change from one to another during the day as the light changed. Towards the end of his long life, the water-lily pond in his garden was an endless source of inspiration.

Landscapes and portraits

These general recommendations also apply to landscape and portrait painting. You may find it helpful not to insist too much on a "likeness" in a portrait, nor worry too much about a sense of distance, or sense of a particular time in a landscape. Concentrate on look-

▼ Detail from a splendidly simple and colourful still-life, "Strawberries and Pineapple" (450mm × 545 mm), by Pierre-Auguste Renoir (1841–1919). Notice the beautifully coloured modelling on the red fruits.

ing, on making equivalents in your touches of paint, and on building the touches up together. Watch out for effects of form and space, but you need not be desperate to achieve them.

"Finish"

A smooth and neat "finish" to a painting can be beautiful, but for the painting suggested in this section, it might be quite inappropriate.

Artists vary greatly in the importance they attach to finishing. One might take great pains to achieve a polished effect, working slowly, intensely and with great conviction. Another

might feel that the effect would lessen the intensity of his paintings.

In the illustrations accompanying this section (the earliest of which dates from 1820) there are no attempts at a smooth surface. Brushstrokes are carefully controlled and sometimes painted into the grain of the canvas, but there is no meticulous "finish".

Reproductions in books can be misleading on this point. Even when they are good enough to capture some of the richness of colouring of a fine original, they are smaller in size, and often neatly surrounded by a border of white paper. The

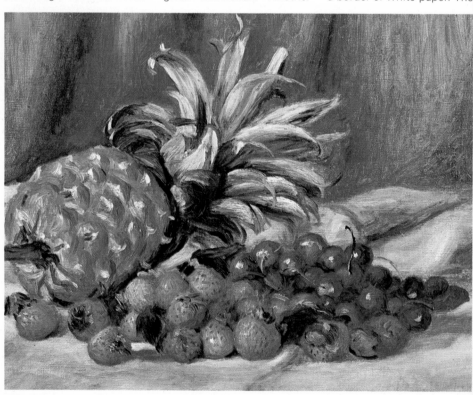

shiny texture of a reproduction gives the impression of a smooth and even surface even to quite rough work.

People familiar with reproductions sometimes feel disappointed when they see an original. It is generally rougher than they had imagined, and even if it is a neat abstract painting, it is probably easy to see that it is hand-made. Some people even prefer the smoothly packaged form of reproductions.

If you are sensitive to painting, however, the force and subtlety of an original work will soon be apparent, and it will not concern you greatly if the smoothness is lacking. Apply the same standards to your own work.

You may decide in some cases that scraping some paint off is better than over-painting. Changing your work significantly at the final stage, or counting it as a finished work with unresolved parts may be necessary if not ideal.

"Deadness" in painting

Paint can look dead because too much oil has sunk into a canvas or board that was too absorbent. Retouching varnish exists to remedy this problem. The varnish is used *during* the painting, to bring up areas which have "sunk". But the thing to aim for, by improving the quality of your priming, is never to need retouching varnish, though "sinking" can be a

▲ Detail from "Apples and Pomegranate", a small work by Gustave Courbet (1819–1877), the determined and heroic realist. These apples are made to have massive weight by the careful judging of tones and thickness of paint.

persistent problem with black or very dark areas.

A painting can also look dead because the colours or tones fail to enliven one another (later chapters will enlarge on this problem). They may look "pasty" because too much white has been used. Oil painters generally use a lot of white, but beginners sometimes use too much of it.

Pre-liminary drawing

Just as good painting is not necessarily "accurate" painting, so good drawing is not necessarily "accurate" drawing. For one thing, good painting and drawing give us something. They do not merely echo something else. For another, there might be several kinds of "accuracy". One portrait drawing might give a strong sense of the character and appearance of a particular person, yet it might have achieved that effect through exaggerations. Another drawing might be photographically "accurate" yet the subject might be impossible to identify; just as some photographs use untypical angles which make familiar subjects unrecognisable.

Perspective and illusion

When children draw a line to represent the ground and a long line or a blue streak at the top of a picture to represent the sky, they are drawing in a logical way. The house is put on the ground and the sun is just below the sky. Between them there is space. That is how it feels to us; we do not *feel* ourselves to be surrounded by blue.

People familiar with the conventions of perspective illusion make the sky and the ground meet at a "horizon". Of course, that is the way that we *see* things.

Drawing and painting need not imitate this aspect of our experience—it can use others. In real life, perspective distortion is much more extreme than we feel it to be, and often much more extreme than most artists would want to show in their paintings.

Try some simple measuring to find out how rapidly objects diminish in size and sometimes change in shape as they get further away

from you. You need not worry about getting things "right" or about drawing procedure; simply study the measurements involved.

Hold your left hand open and place a pen on the palm. The pen is about the same length as the distance between the tip of the first finger and the base of the thumb. Now hold the left hand out, about 500 mm from your eyes, shut one eye and hold the pen up vertically. It should look about four times as long as your open palm. A hand has seemingly diminished to a quarter of its length in only 500 mm.

Try blocking out objects by holding your thumb in front of one eye, whilst keeping the other closed. You can block out a whole building quite near to you in this way.

Get close to a large building and look up at it. The top diminishes. You know that the building is rectangular, yet to draw it you would have to show a shape which, though four-sided,

is nearer to being a triangle.

Look at a cup. The rim is circular, yet the vertical diameter may look less than half the length of the horizontal diameter. What appears to be a fat cigar-shape, a child might well draw as a circle, perhaps with a flat bottom. To the child it is

obvious that a cup certainly has to have a flat bottom if the coffee is not to be spilt. The child is being truthful to what he knows and feels about a cup, and to what he has seen of cups. It is only from the point of view of single focus perspective that he is being untruthful. He is using one focus for the bottom of the cup and another for the top. Many artists throughout history have done the same thing quite consciously, and many modern artists have asserted their right to do this, "feeling" their way through spaces and around solids.

Perspective systems

A perspective system is a way of organising a mass of visual information. It can be a way of laying a scene out

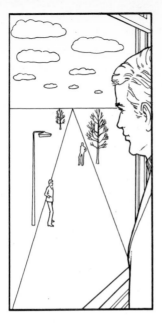

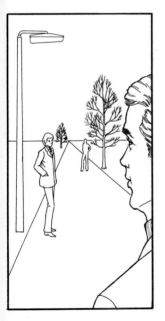

in front of the observer, perhaps as if he were looking at a view from the top of a hill. The subject can get very complicated and is of importance to only a very few artists, but a few simple points can be made.

The first diagram shows a road which is perfectly flat and straight. The lines representing its edges seem to converge and meet on the horizon. The horizon is the furthest visible point.

If you are standing up and are of average height, the horizon will look as if it is about 1.6 m off the ground, in other words, at eye-level. If a person, even a very long way off, is standing on the same flat ground as you, his head will also be on the horizon line (though his feet will not). The trees, being taller, will come above the

horizon line and if they are the same height, they will diminish regularly just as the road does.

The second diagram shows how the scene would look from the top of one of the trees, or from a window at the same level. The tops of the trees are now all on the horizon line. But down below, the people diminish with the road, and their heads never reach the horizon line.

In both of these cases, clouds of the same size and spacing will diminish at a

similar rate.

The third diagram represents the road, but here it goes uphill at one point. The road diminishes at a regular speed, then much more slowly as it goes uphill.

▲ Van Gogh's drawing of "The Road with Willows, Arles". In such a drawing as this he gives an example of perhaps the most stimulating aspect of drawing: the steady exploration of space and of things.

When it reaches a plateau, it resumes the previous rate of diminution. The chunk of rising ground is tilted towards the observer, and at its furthest point is not as far away as it would otherwise have been. Put more technically, the horizon, or vanishing point for that part of the road has been raised.

If you want the road to go *down*hill, the horizon or vanishing point would have to be *lower* than normal.

Painters' drawings

One way of drawing is to use contours, that is, to use a line to describe the shape of the subject. Of course, in real life, the subject will not have a line around it; the line is a convention. Linework has a great disadvantage in that it does not describe the mass of the object you are drawing. It describes the edges, not what goes on in the middle.

Shading is probably the best way of describing a subject more thoroughly. It

can take many forms and has many advantages. In drawing a piece of ground or a person's face, linework will not set you very far in discovering the form of the subject. It is better to *work across* the form, with dots, strokes, smudges, shadings, anything that involves thinking at each stage what the form is like.

In this example from Van Gogh, the artist explores the ground and the space. This is another fascinating aspect of drawing; the way painters' drawings suggest the kind of painting they will do from them.

Van Gogh uses pencil as he would use strokes of the

brush. Bonnard uses little scribbles of the pencil as he will use sensitive touches with the brush. Seurat uses charcoal to build up areas of light and shade, carefully organising the rectangle of the drawing as he will later organise the rectangle of the painting.

The sketches by Cézanne may seem unrelated to painting. The drawings are separate and do not suggest brushstrokes or objects placed in a rectangle. But notice how often the forms are related to their backgrounds. The spoon and the clock are not floating in space, each has its shadow carefully drawn, relating it to table or floor. The shadow around the heads is not de- signed to bring the heads out strongly against a con- trasted background. On the contrary, the strongest con- trasts are often in the middle of the form, and the edges of the head are softest against the background.

Mediums for drawing

Pencil is a beautiful and sen- sitive medium. Remember the varied effects that can be got with the different grades of hardness or softness, and that the type of paper used leads to different results.

There is also charcoal, the greyer kind sometimes called "Willow" and the dense black kind called "Siberian". Ink, used with pen or brush and perhaps diluted with water, crayons, pastels and water-colour can all be used in prelimin- ary drawing.

All these, and frequently mixtures of them, have been used in works that can be called drawings. Each gives a different effect, and can generate more or less en- thusiasm in individual artists and beginners (who should not hesitate to erase where necessary).

▼ A page of pencil sketches by Cézanne, done on the back of a lithograph: "Heads of Hortense Fiquet and Paul Cézanne's Son, with Clock and Spoon" c. 1873–5.

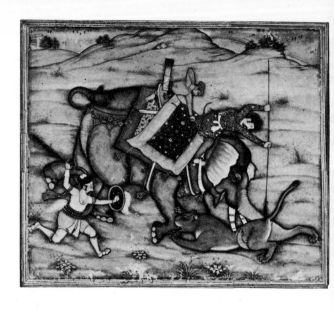

▶ "A Mughal Prince, Spearing the Flank of a Lioness which Attacks his Elephant". Painting from the Mughal period, probably Sur Das, c. 1605.

What is good drawing?

If good drawing is not only, or even necessarily, accurate drawing, what is it? The answer, in broad terms, is simple: good drawing gives us something. It gives us an experience through its energy (it might be spontaneous and exuberant or it might be calm and composed energy) and it evokes, not only an object, a person or a place, but the artist's response to that object, person or place.

In some kinds of drawing, exactness and an urge towards accuracy can be an essential ingredient. In good drawing, several processes can come together, so that an urge for accuracy can exist alongside expressiveness, and at intense moments they can fuse together. But there is no point in making up rules about it; good drawing can take many forms.

Each shape in a good drawing has a particular and specific character. This means that the artist has looked at every possible moment at his subject and never been content to lapse into a formula. If he has imagined his subject, he has thought about it afresh at every stage. Not every part of the drawing will necessarily be an exact copy of the subject, but each will display a fresh energy and a new variety in the handling of the pencil or other medium and the putting-together of the structures.

This aspect of drawing may sound complicated, but it is often found in the works of beginners and of those painters called naive (which is far from being a term of abuse). People may receive a lot of art training, but if they have no vital urge or curiosity of their own, they are unlikely to draw well. Good drawing often has an unexpected quality which may give an impression of awkwardness rather than smooth professionalism, but no great artists have ever pursued professionalism for its own sake. On the contrary, the best artists are those who, however much talent they have, still take the most risks.

Not being too "precious"

No less an artist than Leonardo da Vinci advised against being too precious. He pointed out that a poet feels at liberty to cross out his lines of poetry many times as he gradually shapes and forms the poem. The neatness of the manuscript is not the point, it is the quality of the poem that counts. So, in the explora-

tory drawings that the painter does, he should work over them in much the same spirit, ruthlessly changing them if need be.

It is true that some drawings have a different function from others. Some drawings by Old Masters, for example, are drawings commissioned for portraits, or were to be shown to a patron to give him an idea of the projected work. Here, however, we are considering exploratory drawing, and it is clear that neatness, or the preservation of an immaculately clean piece of paper, may not be necessary.

The beginner's opinion of his own drawing is always a problem. He may have made a serious effort with a drawing and yet the result may not fit in with his idea of what a "good drawing" is. Caution is necessary. The effort may have been good, and the drawing may show it. The beginner should not let too narrow an *idea* about drawing prevent his acceptance of the result.

Drawing in painting

The word "drawing" is also used to describe the shaping of forms in a painting. It was suggested earlier that in good drawing, each shape will have a particular character, an energy of its own. Examining the shape of a human figure in the work of artists as different as Cranach and Matisse, shows that each curve, each hinted straightness, plays an energetic and varied part.

▼ Leonardo da Vinci (1452–1519) "Virgin and Child with a Cat", c. 1478.

Solid form with tone

Shadow is the simplest way of giving the illusion that drawn or painted forms are solid. The circle looks simply like a circle. When gradated tone is added, it looks like a sphere. This simple device can be developed very considerably when forms are depicted and paintings are constructed. In a picture of a range of hills, each hill can be made solid by gradated tone, and above them, a range of clouds can be similarly treated, though here they might blur together more. With one device, a sense of enormous space can be established.

Solidity of form

Shadow does not have to be thick and heavy. Fra Angelico and Piero della Francesa could use the device in the most pale and luminous forms. It can be made heavy deliberately, as in the menacing forms of Magritte.

A single painting can show a good deal of what can be done with shaded solid forms. This great painting is "War" by Henri Rousseau.

The broken branch at the top right is a greenish brown, with lightening on *both* sides (which is what happens when the source of light lies the other side of the object facing us). There is no darkening with black; black is used in this painting as a powerfully emotive *colour* and not as shadow. The forms are nonetheless made to look solid by shading.

The raised arm of one of the people on the ground is again modelled with gentle lightening on *both* sides. The hair, in contrast, simply darkens at the bottom.

One fascinating aspect of this painting is that the black forms are made to look solid without any shading, which would have been impossible on black anyway. Lightening on the black has not been used either, though it could easily have been. The birds, for example, look solid because of their placing and their marvellously expressive shapes. The forms in other colours than black, including the stones on the ground, all show some gentle lightening or darkening.

Contrast in tone, and the lack of contrast

"Tone" is the degree of lightness or darkness in a patch of colour. The dramatic use of contrast between light and dark areas

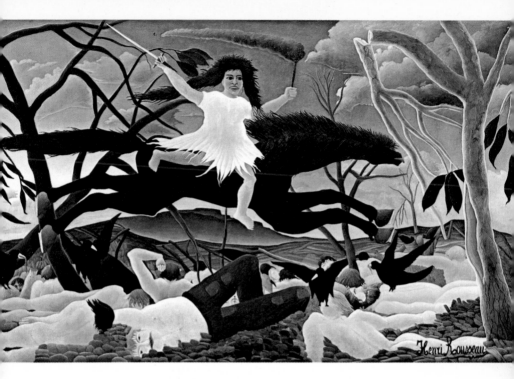

s called *chiaroscuro*. This generally involves throwing a few light and dark areas across the whole surface of a painting, usually with a sense of drama and often of light and darkness being used as symbols; the light of Heaven and the darkness

of man's earthly life, for example.

It is probably more useful to discuss here the control of tones, even of very close tones, rather than the use of dramatic contrasts.

When many colours are being used it is not easy to

▲ "War", by Henri Rousseau (1844–1910) who is called a naïve or "primitive" painter—a great artist who has had significant influence on modern art.

decide how light or dark a patch of colour should be. Blue is normally darker than yellow, unless the blue has been mixed with a lot of white, but whether a red is darker than a green varies endlessly. Tone is not an easy topic to discuss, but the following generalisations are reasonable. Firstly, most of us, not being great artists, tend to pitch the tone of our pictures uncomfortably high or uncomfortably low. Secondly, a strong contrast of tone and a strong contrast of colour *can* co-exist comfortably in the same picture, but it is difficult to get them to do so.

The painting by Rousseau uses colour effectively, and it also uses tone. Both are used in the form of dramatic contrasts of light and dark, and in gentle gradations across a form. In a sense, the means used are simple.

▼ Diego Rivera, most famous of the Mexican mural artists, here illustrated by a detail from a large fresco.

Adventurousness with simple means

But to return to the building-up of a painting simply by means of tone, of shading, of light-and-dark contrasts.

Simple means suffice for the creation of many bold and imaginative paintings. Mosaic and fresco are techniques in which for thousands of years great and powerful work has been done. (The two examples shown are comparatively modern, yet they have a timeless quality). Both mediums require considerable craftsmanship in the preparation of walls, etc., but the surface from the point of view of painterly effect is quite simple compared to the subtle, many-layered processes involved in some easel paintings. Moreover, the breadth of handling desirable in a work which is to be seen from a distance is connected with the development of a sense of scale and of getting the forms to "read" from a distance, rather than the virtues of subtle glazes or fine detail visible only from close-to.

What I am suggesting here is that you can build up a vista, a crowded scene, an historical event or a flight of imagination, by building as with bricks: drawing a form, drawing the form next to it, simple shading, slight darkening or lightening, will bring one form out against another. And so with even a modest control of a few of the basic elements of painting you can develop a work in which a great deal of yourself might be put. This might be a kind of painting in which you begin with outlines, describing areas which you then fill with colour and tone. That is also a time-honoured method of painting, and one in which boldness is often desirable. Do not worry about whether you can draw well, just get the pencil or brush and start working within the outlines.

▼ A view of the building which Juan O'Gorman decorated all over in mosaic. Together with artists such as Siqueiros and Orozco, the Mexican mural painters form a significant part of modern painting; outside the stylistic innovations of Paris and New York, but modern in spirit nonetheless, not least in their social conscience.

Building with colour

Colours can be used in painting for many purposes and one of these is to give a more vigorous effect of solid forms and of space. This use of colour, like other uses of it, such as the heightening of emotional effect, occurs in painting which uses no recognisable imagery at all. It also occurs in paintings of various degrees of realism done from imagination or memory, but here we shall consider its use in paintings made directly from the subject matter, such as a portrait or a still-life. An experience of painting in this way can help to make us more aware of the colours that surround us in our everyday lives. Every single object, with no exception has colour, and when we look hard at it, may prove to have colour of unexpected richness.

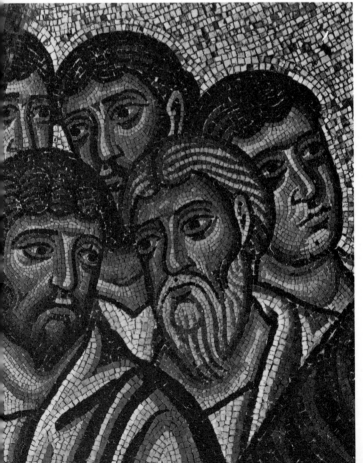

Colour and solid objects

Colour is a great source of energy in painting, not only for its own expressive power, but for its enormous capacity to add to the sensation of form and space.

If we look hard at the light and shade on the objects around us, we usually find that there is a colour variation in them. The shadow, for example, is usually more than just darker than the light, it is usually slightly different in colour. Any objects, whether our own fingers, a cup, a house or a car, will almost always show these colour variations.

This is not to say that the

◀ Mosaic from Hosios Loukos, 12th century. The colours available in mosaic are restricted, so that small changes of colour or tone, or changes from cool to warm, must suffice.

colour of the object has abruptly and drastically changed; the variations may be almost indescribable in terms of bright colour. The change, however, is often one from "cool" to "warm", or vice-versa. The cool colours are usually described as moving towards blue or green, and the warm colours towards orange and red, and yellow. It should be remembered, however, that some reds are rather bluish, rather crimson in colour, and are therefore cooler than other reds. Similarly, Lemon yellow is greener, and therefore cooler than a full cadmium yellow, and Raw umber is greenish and therefore cooler than Burnt umber.

A finger, or a cup of coffee, however, may be neither reddish nor greenish nor any other colour very clearly, yet there are subtle variations of colour on it. How can these be shown and used?

In some cases, simply darkening a colour to show that a form is solid can work very well. Artists of the past often used a single colour, say a flesh colour, on top of a preliminary cool colour. The top layer of paint was allowed to go thin in certain places so that the colour underneath lent some of its coolness without a clear change of colour being

▶ In this detail from a self-portrait by Van Gogh, the form is built up with hardly any contrast of tone.

evident.

Painters since before the Impressionists, have tended to put touches of pure colour together to get a vitality of colour comparable to the vitality that light gives to the things we see. Other artists had done much the same, and something similar is almost inevitable in mosaic of any period, but the Impressionists and simi-

▼ The colour circle. This contains the three primary colours: red, blue and yellow, and the three secondary colours: orange, violet and green. Complementary colours are any direct opposites, for example, a bluish green against an orangey red, and so on. This is indicated by the dotted line.

lar artists used patches of pure colour to an unprecedented degree. Their paintings may look rather flat, but their colour added to their drawing can also give a strong sense of form and of space.

Modelling a solid form by colour changes (they are likely to be tone changes as well, to some degree) can give a greater sense of solidity. The colours used will presumably be closely related to those seen, yet a seemingly arbitrary choice often has to be made.

It should always be remembered that painting works within limits of tone and colour which are not the same as those of our visual experience. Any art has its limitations and conventions, and these can be-

come a source of strength.

Waiting for forms to emerge
Sometimes, in putting down strokes of colour, which from close-up, seem to offer little contrast, you may feel that forms and spaces fail to emerge. If you are doing a mosaic you may think, for example, that the edge of a face made with a pinkish stone against a cool pink stone background, would not stand out at all. In fact, if you do this and then stand back and look at it from a distance, the face may stand out very astonishingly. Sometimes you have to wait for the form to emerge.

Colour theory
This book does not describe colour theory or composition theory in great detail, because both can be very inhibiting. Good painters use their knowledge in a thoroughly digested way; it is *behind* them, helping. To learn too much theory too soon is to have it standing in *front* of you, blocking your progress.

A little theory, however, may be useful. The three "primary" colours are red, yellow and blue. The three "secondary" colours are each mixtures of two of the primaries; orange, green and violet. The term "tertiary" is also used. It means mixtures of all three primaries, such as the browns.

Primaries and secondaries are usually set out in a circle so that the further term "complementaries" can be

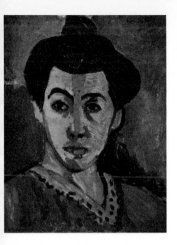

▲ Matisse (1869–1954):
"Portrait of Madame
Matisse" (or "Portrait with
the Green Stripe"), 1905.

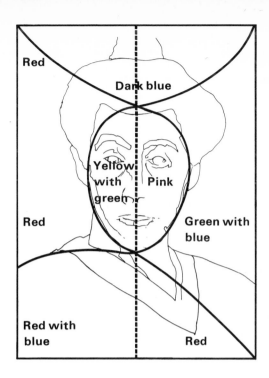

easily defined as direct opposites. Blue is the complementary of orange, red of green, yellow of violet.

These complementary contrasts are important because they give very energetic effects. Many paintings are based on such contrasts, and probably the most common of all is red and green.

A painting might be based on a cluster of reds, with a contrasting note of green or a cluster of greens. Van Gogh's famous painting of his bedroom is based on a beautiful balance between a cluster of blues and a cluster of oranges. If you doubt that he consciously used such contrasts, read his letters and the doubt will disappear.

Look at paintings of any period and try to find out whether they are based on complementary colours. Some will not work in this way at all, but you will certainly find many that do. Many will also use two pairs of complementary colours, with one subsidiary to the other. Such devices in a good painting are not rules, but more like musical instruments which a composer will find out about, and then use with increasing freedom. Red, blue and yellow and their opposites are basic colours to the painter, and manipulating them becomes second nature to him.

Harmony and contrast
Colours appear to change according to the colours which surround them. A plain, medium grey, when surrounded by an orange, will seem astonishingly blue. This is one form of the well-known "after-effect" phenomenon. If you stare hard for a while at a square of paint of a very bright colour, then transfer your gaze to a blank white wall, you will see a square of the complementary colour on it.

Colours also change according to the colours which are near them. A spot of bright red in a painting, for example, can activate the reds in other parts of the painting. A patch of dull reddish-brown somewhere can look brighter because of the spot of bright red. Paint

over the spot of bright red and the duller colour will lose its new vitality. This phenomenon involves harmony, and the power of harmony is not easily fully realised.

When you use paint, you are not using some ideal colour, but something which has been made out of a pigment. You will not have pure blue, but perhaps Cobalt blue which is greenish, or Ultramarine which is purplish, and so on. The fact that pigments are not ideally "pure" colours is an advantage. As Ultramarine is purplish it will function to some degree as a harmony with red, and a contrast to yellow. The possibilities of harmony and contrast between pigments are endless. They are a source of the richness and subtlety of painting.

Analysis of a very bright painting

The painting reproduced on page 57 is by Henri Matisse. We have also reproduced some diagrams of the colours on the previous page. Notice the unusual device of a green stripe down the centre of the face (the red mouth breaks this line). The green line is presumably the darkest shadow; the side of the face to our left is also in shadow, but receives some reflected light.

A face can really have a cool shadow side with reflected light, a central dark shadow and a warmly lit side. The background could also be warmer against the cool side and cooler against the warm side. Here, however, the colouring has been pitched at an astonishingly bright level, with its shadow of bright green; yet the warm part of the face is convincing as flesh colour and the shadowed side is quite conceivable.

This, therefore, is a painting which is built up with bright slabs of colour, yet still respectful of the colours and shape of the original, the face.

The green stripe gives a sense of the painting being in two halves, bright reds on one side in the background, bright green on the other. The face is a reversal of the background red and green, though the colours are here in a key more appropriate to a face.

Blue is introduced towards the top and bottom. Not only is the hair blue, but there are bluish colours to either side of it. This is why the blue hair does not look too extreme,and why it sits back comfortably. There is also a greenish-blue top to the dress, blue lines are used to outline the dress, and part of the dress is bluish-red.

This painting could have been too symmetrical, but Matisse places the face slightly to one side, making its gaze point still further to the left. There is a patch of such bright red on the left that it might pull our gaze completely to that side, but streaks of bright red pull us back, to the mouth, the ear, to the streaks on the dress, and to the orangy red in the bottom right-hand corner. So the picture gently picks up a diagonal movement from the top left down to the bottom right, a movement emphasised by several brushstrokes on the dress, face and hair.

In reading such a detailed description of a painting, people sometimes ask whether the artist could possibly have been thinking of all these things. Their question is a strange one. Nobody doubts that a top scientist, chess-player, sportsman, or anybody who works at a high level of complexity, has to hold a great deal of experience and an awareness of a great many possibilities in their minds. It is inevitable that a top artist will do the same. Imagine a great violinist playing even a rapid and light-hearted piece; he would not be content to play a mass of accidental notes. A good artist, and above all a great artist, ponders his next move as he holds his brush in his hand, with as much complex mental activity, working on as many levels of consciousness, as a master in any other field of achievement.

▶ Matisse: "Portrait of Madame Matisse" (or "Portrait with the Green Stripe"), 1905, (detail).

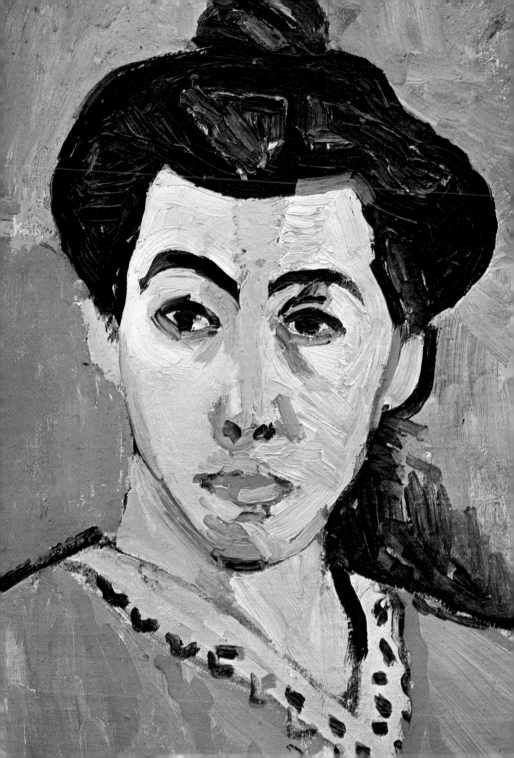

Com-position

As with colour theory, the technique of composition can become merely laborious and inhibiting. A good artist, however, will be able to use constructional devices with such ease and freedom that there is nothing stiff about them. The student should at least know that these techniques exist, and should also know that they can take many forms. The three forms of composition discussed in this chapter are the diagonal, triangle and spiral.

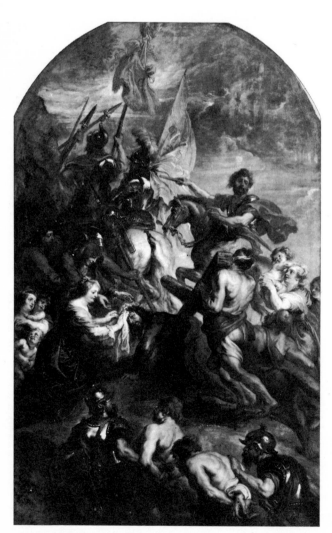

There are many forms of composition that can be studied. One can analyse for example the main lines of movement in a fine painting or the main divisions that cut across the rectangle of the canvas, dividing the painting up into different areas. The balance of the main masses of form, space, and colour can also be analysed. Perhaps the artist has balanced one aspect of the construction against

◀ Rubens: "The Ascent of Calvary".

another, or perhaps he has distorted the constructional lines for expressive effect, just as he may have distorted the contours of a figure.

Composition is complicated and it is better to ignore rules entirely than to try to apply rigid theories. The three examples illustrated are great and complex paintings. It should be clear that the remarks made about them only indicate a tiny fraction of the thinking that has gone into them.

The diagonal
A diagonal line running from one corner of a painting to another has formed the basis of many compositions. Sometimes two diagonals are used, generally with one of them less marked than the other. The diagonal is a strong constructive device, usually suggesting dynamic

▼ Picasso: "Guernica", 1937.

movement. Rubens, in this huge painting, has chosen the diagonal as appropriate for the subject of Christ's ascent of Calvary. Strong movement surges upwards and to the left, whilst smaller movements cut across at right angles. Look at, for example, Christ's arm, the bar of the cross, the horse's nose, the dark line of the woman's back. These details provide a counterpoint to the main movement, suggesting the halting progress of the group as it ascends the hill. The flag suggests something else; a main triangle in the painting, picked

up gently rather than emphasised. It takes nothing away from the diagonal movement, yet it gives an element of stability.

The triangle
The triangle is perhaps the most familiar and frequent of all compositional devices (of the linear kind), and is often mentioned in connection with the marvellously peaceful effects achieved by Raphael in his paintings of the Madonna and child. A triangle firmly based on the bottom of a painting gives an impression of stability.

The example chosen here

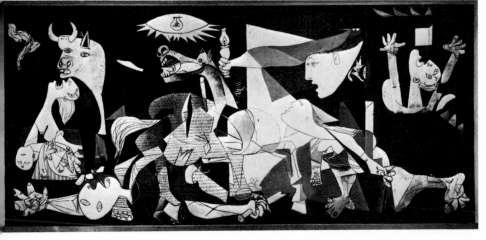

is more surprising. A huge triangle is used in one of the most violent paintings of this or any other century, Picasso's astonishing vision of the bombed Spanish town of Guernica. The base of the triangle here stretches across the 7.6 m width of the canvas.

The spiral
The spiral is another of the numerous possibilities. In Raphael's "St Catherine", the saint rests her arm on the wheel with which she was martyred, and raises her eyes to Heaven. Through the painting many wheel-shapes, which perspective tilts into ellipses, twist and turn into the form of a spiral which eventually passes from St Catherine's face into the sky.

Allowing compositional devices to work
Some sort of compositional pattern may emerge as you paint. Let this happen and watch how the pattern evolves. Proceed by feeling and intuition rather than by trying to rationalise a composition because there are many aspects of composition, and you will hinder their development if you only use those you know about.

The "Golden Section"
The term "Golden Section" is used to describe a mathematical theory of perfect proportions which was first developed in the ancient world. It is most commonly used for dividing lines and rectangles in such a way that the relationship between the smaller part and the larger part is the same as the relationship between the larger part and the whole.

Too much time is often wasted on the "Golden Section". People normally divide lines or rectangles with it, totally failing to relate this procedure to images, masses or symbols.

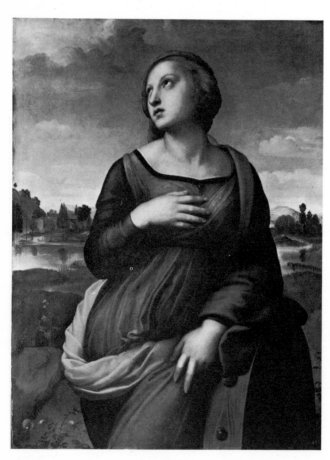

◀ Raphael (1483–1520): "St. Catherine of Alexandria".

Exploring with colour

The second suggestion about beginning a painting was to put down a colour with no pre-conceived idea, and to add to it and put down other patches in an intuitive way. A good painting of any kind has an energy of colour and shape. Some painters concentrate on this energy and are quite happy to leave out recognisable images altogether. Indeed, many painters would see it as a positive gain that the colours and shapes in their paintings are not encumbered by the additional and complicated duty of having to represent some familiar object. Other painters have achieved this experience in a deeply felt way, but find it finally unsatisfactory. They are grateful to abstract painters for being stimulating about what are after all, basic qualities in painting, but feel that recognisable images are essential.

▼ Wassily Kandinsky (1866–1944): "Romantic landscape" (1 m x 1.3 m).

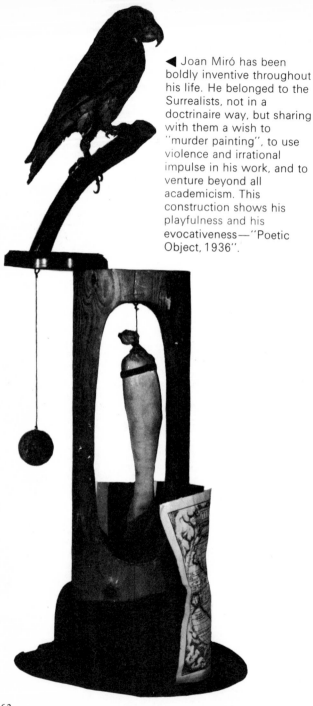

◄ Joan Miró has been boldly inventive throughout his life. He belonged to the Surrealists, not in a doctrinaire way, but sharing with them a wish to "murder painting", to use violence and irrational impulse in his work, and to venture beyond all academicism. This construction shows his playfulness and his evocativeness—"Poetic Object, 1936".

Choose a colour and put some of it down on your board or canvas. Look at it and find out what comes into your mind about it. Does it look as if it demands to be expanded or given a particular shape or other colours started up in the picture?

The other colours can harmonise, contrast, or be quite independent of the first. If the first colour was red, an orange would contrast, and a blue would be independent. Your painting might not represent anything at all, yet the colour patches could be like people living together. Do they conflict or harmonise, cramp or enliven one another?

This analogy takes us a stage further. If we speak of "living together" surely that means there is already some kind of organisation in the painting.

As you group the colours, or add to the painting to develop it, you might sense an order which you cannot explain. It may be all the more effective for being elusive. The shapes and colours you are using hint just enough at some kind of compositional structure, perhaps a kinship between shapes, like variations on a theme in music. The painting may begin to suggest depth and space, or it may have a continuous flat quality, like a carpet.

Painting in this way can be useful to you as a loosening-up exercise in which you can let yourself go with shapes and colours as you

might not do otherwise. If you normally paint from something in front of you, you may mix colours so much that the joyful energy colour can have, has never revealed itself to you.

Three artists
Since this is a difficult subject, it is useful to look at three artists capable of great exuberance and invention. Kandinsky was a Russian, a serious and dignified man who began by studying law, but who later began to paint. In his 40's, Kandinsky not only matured, but burst into a period of energetic creativity in which he became famous for producing the "first" abstract paintings. This explosion of energy was caused by the realisation that painting could be invented freely, just like music.

Beyond the flat surface
Miró offers another example of wide-ranging invention, and has explored beyond painting on flat rectangular surfaces in his sculptures, and assemblages. Miró's world is more disturbing than Kandinsky's; sometimes comic, light-hearted and playful, sometimes savage, troubled and painful.

Mondrian
During his maturing as an artist, Mondrian simplified landscape and seascape increasingly to a few powerful horizontals, and simplified views of cathedrals or windmills to powerful verticals. His mature work uses black lines on white squares, and square areas of pure primary colours, with an always assymmetrical balance, to produce severe but beautiful and satisfying effects.

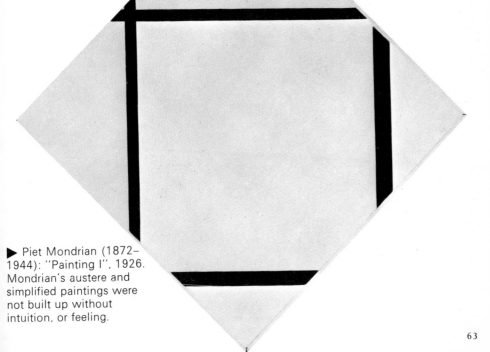

▶ Piet Mondrian (1872–1944): "Painting I", 1926. Mondrian's austere and simplified paintings were not built up without intuition, or feeling.

Painting from imagination

Simply to paint pictures, straight out of your head, is the most natural and universal way to paint. From the great figures of animals done on the walls of caves many thousands of years ago, through the more complex wall-paintings of Greece or Rome or China or India, through the Renaissance period in Italy with its cycles of frescoes on religious subjects, painting is imagined. If we walk through one of the national galleries looking at paintings of many centuries, the great majority of the paintings we see of any century will be imagined.

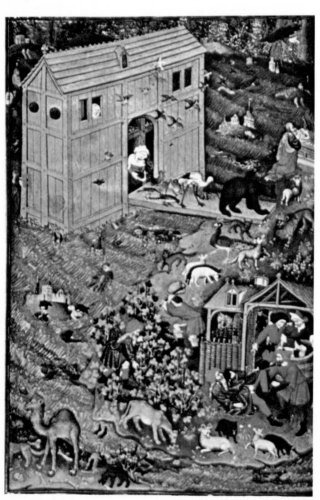

◀ The Bedford Book of Hours: "Leaving the Ark" c. 1423.

The third approach suggested on page 36 is painting from the imagination. Beginners sometimes feel that imaginative painting will expose their limitations, almost as if they will "fail" in some way. Yet most artists, from the cave-painters to the present day, have worked in this way. The great Renaissance artists are thought of as realistic because they used techniques of convincing anatomy and illusion. Yet Leonardo, for example, imagined his "Last Supper" scene—he did not have his subjects sitting in front of him. In essence, all painting is imaginative, but some painting uses exploration of the real world as part of its imaginative process. Perhaps most beginners' fear, when they try to paint simply from the imagination, is the fear of venturing out into a vast area of possibilities without a compass. In fact, our own sense of what we like or value is our compass,

n this as in any other activity. Imaginative painting is simply the process of taking aspects of our world, of our experience, and assembling them on canvas in a way that seems good to us.

If you want to represent people in a room, you will be painting the floor or the walls you have seen, even if you intend to improvise

▼ Georges Rouault (1871–1958), like Matisse, studied with the Symbolist painter Gustave Moreau Rouault was a deeply religious man who painted prostitutes, clowns, the face of Christ, and many scenes involving human experience of pain and isolation. Below is reproduced "Winter", a painting described on page 67.

great changes in them. Your people will still represent people, even if the proportions of your figures are wrong anatomically. They may be right according to feeling and they may fit in well with the other parts of the painting.

There are great advantages to painting imaginatively. Admittedly, the result may seem raw or unsatisfactory to you in some ways, because it lacks polish, or confident drawing of every item in the picture. You may for example have drawn part of a figure vigorously, but be baffled about the legs and feet and how they stand upon the ground. Even to have that sort of problem may seem amateurish or comical to you, but it is not, and your attempt to

solve it may be better than you think. If it lacks confident skill and anatomical knowledge, it may still have a feeling of the experience of legs and feet standing upon ground which may be every bit as genuine and varied as a more "skilful" version might be. It cannot be emphasised too much that good painting is not realistic painting; good painting may be vivid, joyous, expressive, personal, idiosyncratic, all sorts of things, including perhaps realistic. Too much emphasis on realism can easily work against all the other interesting qualities that painting can have, whereas if you imagine a painting, all that is in it will be your own, part of your experience, and it is very likely to be

▲ This is a part of the painting "Les Funerailles d'Alexandre" by André Bauchant (1873–1958) whose warm and personal paintings are of value whether or not they are labelled "naïve".

vivid and personal.

All of the suggestions made earlier can be brought to bear on painting from the imagination. For example, the building up of solid forms by the use of shadow, or the fact that painting is invention.

Imaginative exploration can be careful and gradual. In the drawing on page 44, Van Gogh used little strokes to explore the length of the path and back into space. Examples of painting to illustrate working imaginatively might have included vast cycles of Italian fresco paintings or huge visions from the French artists of the early 19th century—the possibilities are endless, but it is hoped that each makes a useful point.

Small paintings

"Leaving the Ark" from the Bedford Book of Hours is a small painting (250 mm x 145 mm). The beginner should never feel obliged to work on a large scale, or to use paint thickly or roughly. Beautiful effects can be achieved on a small scale, perhaps with water-colour and a fine pointed brush.

You do not need to amass information about your subject. What you already have is enough.

"Flattened" perspective

It is worth remembering that the perspective used in a work like this illustration is of a deliberately flattened kind. It is perhaps best described as a perspective in which one's eye moves around, focussing now here now there, and keeping more or less equally close to things, whereas what is commonly thought of by us in the West as "perspective" is the rigidly single-focus system whereby the eye is thought of as still, so that everything rapidly diminishes to the horizon. Byzan-

tine, Chinese, Indian and other schools of painting normally use a perspective with a moving focus, which has many advantages, and to which many artists have returned this century. There are many possibilities. Michelangelo in his frescoes on the ceiling of the Sistine Chapel naturally used a separate focus for each individual scene, with many variations and dizzying jumps of scale.

▼ Morris Hirshfield was born in 1872 in Poland, and in 1890 emigrated to America. He started painting only in 1937 when he retired from his business. Shown below is "Tiger", 1940.

Rouault

Rouault's "Winter" is painted on paper with diluted oil paint and pastel. Rouault was deeply religious and loved the tradition of painting. His own works are generally very small, but display an unprecedented violence of paint handling combined with a powerful sense of structure. His works are on permanent display in Paris, and they show how forcefully paint can be applied, and how timidly most people use it in contrast. An early painting is chosen here, to show an unusual medium and the bold simplification of Rouault's figures.

Rouault's simplications have nothing to do with

naiveté or lack of professional skill. As with Picasso or Chagall, Rouault's great skill and technique are beyond question, but (as with them) great expressive powers demand something else than the exercise of technique. If we turn to look at the artists who lacked such skill to the point where they are described as "naive", we find many who nevertheless achieved remarkable things. André Bauchant painted homely scenes of birds in the trees, or lovers in the fields, and would also tackle imaginative subjects with great intensity and individuality.

Hirshfield

The American artist Morris

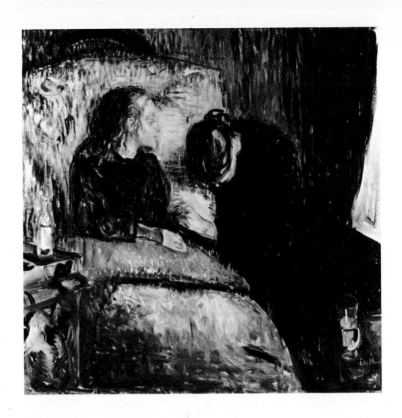

▲ Edvard Munch, one of the great figures in modern painting, was Norwegian, and was influenced by Van Gogh and the intellectual atmosphere of Paris. This is "The Sick Child", 1906–7.

Hirshfield began painting seriously only after he had retired from business at the age of 65. His works are greatly valued for their vividness and imaginative force. They are painted carefully and with a strong sense of pattern and of the energy of shapes.

Munch

Edvard Munch, one of the great figures in modern painting, is perhaps not as widely appreciated as he might be, because few of his paintings are in public museums outside his native Norway. He was one of the first Expressionists. He was a troubled and uneven artist, but the finest of his paintings, drawings and prints have an unparalleled, fierce directness of expression.

In these examples I have stressed two of the great modern Expressionist artists, and two of the most fasci-

nating "naïve" artists since the Douanier Rousseau (so called because of his service as a customs official). These examples illustrate particularly valuable aspects of painting since they are all equally remote from the excesses of the various kinds of slavish realism and from the self-conscious concern with stylistic innovation. If you are painting from imagination—and for many people this is probably the most stimulating kind—such excesses and such self-consciousness are likely to be only a nuisance.

Water-colour and other mediums

Water-colour is paint made of pigment ground with an adhesive such as gum arabic, and thinned with water. It is normally used on paper, but can be used on other very absorbent surfaces. It is a very beautiful medium with clear, transparent colours. Though it is a simple medium, it is not necessarily an easy one to use. Gouache, pastel and acrylic paint are mediums also dealt with in this chapter.

Pigments

White water-colour is seldom used, because the white of the paper shows through the paint. The more water that is added to a colour, the more white shows through and the colour becomes lighter in this way. Otherwise, the colours suggested for oil painting on pages 27 and 28 can be used for water-colour. They are standard and permanent colours and it is advisable to get to know a basic range thoroughly.

Brushes

Soft brushes, such as sable, are normally used for water-colour. If you can afford a fairly large, good quality sable, it will be an advantage. It will be big enough to hold a generous amount of paint and so help to avoid a niggling effect. If it is good quality it will also come to a fine point for detailed work. As you will keep

▶ "The Ancient of Days" by William Blake (1757–1827) who was a great poet and visionary and produced extraordinary etchings and paintings, including illustrations to the Book of Job and to Dante.

▲ Types of brushes suitable for water-colour.

plenty of water near you and wash the brushes frequently, you do not need a large number of brushes. You may find a big, flat-ended brush useful for washes of paint, and perhaps a smaller pointed one useful for finer effects.

There are cheaper soft-haired brushes such as ox-hair and squirrelhair. Some of these can be excellent, but others may prove too limp and even the small brushes may not give a fine point.

Paper
Ordinary cartridge paper or other quite cheap paper can be used for water-colour, though the paper should preferably not be thin, smooth or shiny. Papers specially made for water-colour are of varying thicknesses and degrees of roughness of surface. They are not necessarily white, though most water-colour painting is done on white because the white surface gives a radiance behind the colours, and can also be used as an element in the painting.

Unless you use thick, heavy paper or cardboard, you may find the paper

"cockling" or wrinkling; this can be a nuisance, especially for even washes. Paper can be stretched, as shown in the diagrams, and will then remain flat while being worked on.

To stretch paper, you need a drawing board or similar piece of stiff, hard board. This must be rather bigger than the paper. Damp the paper with a wet sponge or cloth, and wait for a while. (Heavy papers need to be thoroughly wet, but simply wiping the surface will do for the average paper.)

▼ A typical water-colour palette.

Waiting is important. The paper will stretch slightly, perhaps curve up a little, then settle down more limply. Then put brown sticky paper all the way around the paper to fasten it to the board. It will dry out, stretched taut. When the painting is finished, cut it off the board.

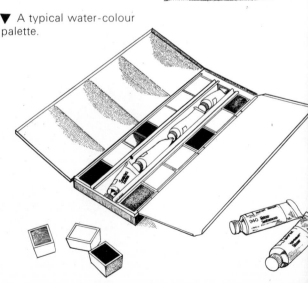

Palette

The palette illustrated was bought without paint. The advantage of this is that it can be filled with your own selection of colours, either in pans or in half-pans. Some palettes have a water bottle fitted to them, and they always have an empty space for brushes in the middle. If you carry brushes around *outside* the paintbox make sure the hairs are protected.

A palette is more obviously useful for water-colour than for oil painting, but it is not indispensable. Saucers or plates can be used instead. A sponge can come in useful, and you will need a water jar if none is included on the palette.

Differences between water-colour and oil painting

Any subject that can be treated in oil can also be treated in water-colour, but there are differences in the effects that come easily to each.

The biggest differences are in tone and in the weight and presence of the paint. Oil paint is heavy and can be applied with some thickness and density so that it can give a sense of real substance to the subject represented.

Water-colour gives a lightness of effect. It is more like a stain than a layer of paint asserting itself in its own right. The observer is also aware of the surface of the paper beneath the paint. A sense of reality is still possible, but it is generally a different aspect of reality, often a reality of airy spaces and atmosphere.

Another difference concerns size and scale. Water-colour can be applied very freely and vigorously, but the scale is likely to be smaller than in oil painting, not just in size, but in feeling. Water-colour lends itself well to detail and delicacy.

▼ The English tradition of water-colour painting is almost entirely one of landscape, often stressing evanescent effects of clouds and light. "River with a Group of Buildings and a Barge" by Thomas Churchyard (1798–1865).

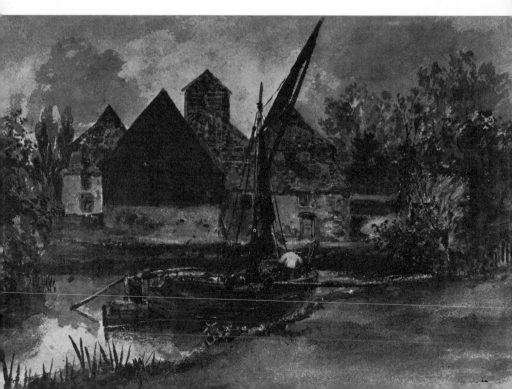

▲ Emil Nolde (1867–1956): "Red Poppies". In his oil paintings, Nolde used thick, heavy paint for his expressionist effects, but in a water-colour he might use paint with striking directness.

The range of possibilities

The admirable illustrations in the children's books by Beatrix Potter are fine examples of the detail and delicacy possible in water-colour. Great vigour, however, can also be achieved.

The first illustration in this section shows this quality. William Blake's "The Ancient of Days" is an example of water-colour used in a highly imaginative painting.

Thomas Churchyard painted landscapes in the English tradition.

The flowers by the modern artist Emil Nolde show the rapidity, freshness and vividness of which water-colour is capable.

These are only three examples. We might also have shown an Indian painting, a tiny "miniature" portrait from the 17th century, or a landscape or figure painting by Gauguin. Picasso and Beckmann occasionally used water-colour to depict Surrealist visions. We might have shown a very realistic, exact and detailed modern work by Andrew Wyeth, or a construction by Paul Klee. Water-colour cannot be called a restricted medium when so many different effects are possible.

Opaque water-colour

The white that can be used with water-colour is called Chinese white, and using it changes the whole feeling of the water-colour. Its opacity sets up effects which are quite different from transparent washes. It can be used sparingly, or as a special effect; to show the white blossom on a tree, for example. If it is used exten-sively, the painting would become a gouache.

Gouache and designers' colours

Gouache colours can be bought in tubes. They are water-colour made opaque with additives and can provide a very satisfactory medium, and for some people a good medium to begin painting with. "Designers' colours", "poster colours" and so forth, might also be described as gouache, but are not always made with the same intentions as artists' quality oil paint or water-colour. The colours are sometimes fugitive, that is, they fade very quickly. This is not a criticism of them, they may be very suitable for design work which is going to be reproduced mechanically, so that permanence of the original is not important. They are not suitable for a painting which is intended to be kept permanently.

These ranges of paint often have strange names and strange tints, which can cause difficulties. You may not be able to become familiar with a range of standard and dependable colours as recommended in this book. The result may be a loss of character in your colouring, though this, of course, depends on the individual.

Some colours with

▶ Samuel Palmer (1805–1881): "In a Shoreham Garden" (290 mm x 220 mm). Detail

▲ These are two sections of a delightful 14th century Venetian work, "The Altarpiece of the Virgin Mary".

strange names, however, are simply new types of pigment. These can be excellent, and worth getting to know just as the older colours are, phthalocyanine is an example (sold under several trade names).

Egg tempera painting
There is not space enough to describe here all of the mediums known as *tempera*. A brief account of the kind using simply egg, may, however, be of use to people wishing to try this medium.

Preparing a surface for tempera painting
The surface for tempera painting is called gesso—a white material, not unlike plaster, which is coated onto a rigid supporting surface such as wood or hardboard.

The board should be given two thin coats of size to make it less absorbent (the smooth side of hardboard has first to be sandpapered).

Gesso takes several forms; a modern method is to sift whiting into a warm glue-size, some zinc-white (powder) perhaps being added to the whiting for additional whiteness. When the mixture has reached a smooth, creamy consistency, a first coat is brushed evenly onto the board ensuring that there are no air bubbles. After a few minutes a second coat can be brushed on, and further coats at gradually lengthening intervals. The gesso should be left to dry over-night.

The next day, when it is dry, the gesso surface will be white instead of the darkish colour caused by the water in it, and the painting can begin immediately.

The paint
Pure pigments in the form of powder (not to be confused with "powder paint") should be used and ground or mixed thoroughly with a mixture of pure egg yolk and water. You would probably use a very small sable brush, and small, repeated strokes of colour. It will become surface-dry almost immediately.

The cost
Most of these materials are fairly cheap. Whiting and hardboard are not expensive, and glue-size is used in such small quantities that

it lasts a long time. Only a small quantity of egg is necessary. The pigments are the main expense, and vary surprisingly in price from the cheap "earth colours" to expensive Cadmiums. But once again, the pigments last a long time after the initial expense, partly because very little is used and partly because, being pure, the colours are very strong.

Tempera, then, is not a very expensive medium, nor is it necessarily very complicated or time-consuming. The procedures involved, however, and the difficulty of becoming fluent with the medium, may limit the number of people who wish to take it up.

The range of possibilities

A considerable number of paintings have been done with egg or an emulsion of egg and oil over the past centuries. In the present century, several great artists have made at least a few experiments with some kind of tempera (Picasso, for example), or made some prolonged use of it, perhaps in a personal way (notably Paul Klee). Abstract painters have used tempera (Mark Tobey, for example), or realistic painters such as Ben

Shahn and Andrew Wyeth. The little-known but remarkable English artist Edward Wadsworth had a fine command of tempera technique.

Egg paint and gesso ground both dry very rapidly and they also become increasingly hard over the years. Moreover, egg tempera does not yellow as oil paint does to some degree. Tempera is one of the most permanent of all painting mediums.

Pastel

Pastel is pigment in a powder form, made to cohere into stick shapes with a small proportion of gum. (Oil pastels do exist, but their permanence varies.) As with the other mediums it is

probably best to buy the standard permanent colours. With pastel, a variety of tones is available within each colour and some lighter tones of each will prove useful.

Cartridge paper can be used, but it is worth trying papers with a rougher texture, and not necessarily white. The pastel colours are opaque—quite unlike water-colour or tempera—and a white surface does not have the same importance. Even a black paper can be used, though a medium-tone paper has the advantage that the artist can work away from it in both directions, to lighter or to darker tones.

A finished pastel is usually sprayed with "fixative" so

▶ Edward Wadsworth painted abstract paintings, or detailed realistic paintings, sometimes with undertones of Surrealism, in a fine and scrupulous tempera technique. This is "Lifeboats" of 1944.

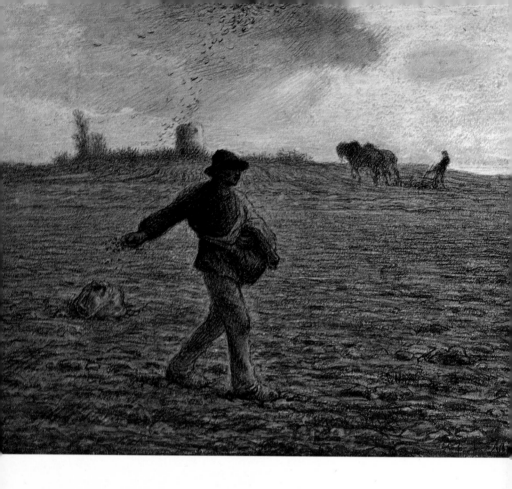

▲ Pastel can be used for quick sketches, for quite delicately finished work, or even for effects of space or massive form. This is the "Sower" by Jean-Francois Millet (1814–1875).

that it does not smudge. The fixative can change the appearance of the pastel very slightly, and destroy something of its freshness, especially when pastel layers have been rubbed into each other and smeared on heavily. Some people prefer to put the pastel under glass for protection, without spraying it. Pastels should be put under glass anyway, but the glass should not touch the pastel.

Pastel is another medium that does not yellow as oil paint does. There are fine pastels by 18th century artists such as Chardin, 19th century artists such as Degas and Renoir, and the medium is still in quite frequent use.

Acrylic painting
Pigments ground with an acrylic emulsion form a comparatively new kind of paint. It dries quickly, is considered to be permanent and not to yellow or darken. Acrylic paint adheres to a wide variety of surfaces, whether primed or unprimed (though not to a greasy or dirty surface, of course). It is a medium which may yet be developed considerably, but at the moment it has disadvantages which, for

some artists, offset its great advantages.

The strength and quality of some colours may be less good than in other mediums. The speed with which it dries can be a disadvantage in some methods of working, and some people dislike its texture, especially when it is used thickly. The "earth colours" also lack the subtlety and vigour that they have in other mediums.

All this may vary from make to make and may yet be improved. It remains a very flexible medium with great advantages.

The example shown here is by the American artist Morris Louis. Helped by a famous paint manufacturer to get the consistency of paint needed, Louis used devices, rolling and trickling paint on raw canvas, to achieve paintings of great purity. Similar devices had been used by other artists working in a Surrealist or abstract manner, but many people consider that Louis reached a clarity of effect that was utterly his own.

▶ Morris Louis (1912–1962): "Flare", 1961. The paint being allowed to flow down the canvas—of course in a carefully judged way—helps the feeling of purity as finicking brushstrokes could not (234 cm x 91.4 cm).

A short history of painting

It must be remembered when looking at a chronological account of painting that though styles of painting change, painting does not develop in the sense of getting better. Different civilisations have different characteristics and attitudes to reality. To underestimate the great achievements of civilisations simply because they are not the same as our own shows lack of understanding.

Prehistoric painting
c. 40000–3000 B.C.
The earliest paintings have been found on the walls of caves. Cave painting was a long, developing tradition covering many thousands of years, done by powerful artists whose imaginative and expressive creations still affect us deeply. The most extended groups of cave paintings include those at Lascaux in France and Altamira in Spain, famous for their splendid paintings of animals, and at Tassili in Africa with its beautiful and lively human figures.

Egypt
c. 3000–1000 B.C.
The Egyptian painting that has come down to us is mostly in the form of paintings on papyrus or reliefs made from limestone, or wall paintings. They show not only extraordinary qualities of pattern, colour, rhythmic spacing and drawing, but vividly convey to us a sense of the everyday life of the time.

▲ Painting of a bull from the Lascaux caves.

Later Egypto-Roman art includes the striking realism of the encaustic portraits from Fayum mummy cases (early A.D.).

Greece
c. 2000 B.C.–A.D.
The Greeks—to judge from the great achievements of their civilisation and the power and vigour of their sculpture, as well as by written report— reached great heights in

painting. But what is left now consists of painting on pottery and very little else. This cannot give us an adequate idea of what has been lost, which included an unprecedented use of the illusion of reality. A row of Greek vases badly displayed can give an impression of repetition, with endless black figures silhouetted on red, and so on. But a varied display, or a closer study, will start to give us the intense and exhilarating experience which can still come from the Greek arts, and which, briefly, is indescribable. Greek wall painting, almost entirely lost, still speaks to us through copies, fragments and Roman imitations.

Rome
146 B.C.–400 A.D.?
Roman artists, heavily influenced by the Greeks, have left us more examples of painting, technically admirable in fresco and mosaic. Perhaps the most beautiful remaining works are the wall paintings at the Villa of the Mysteries in

▼ Egyptian figures.

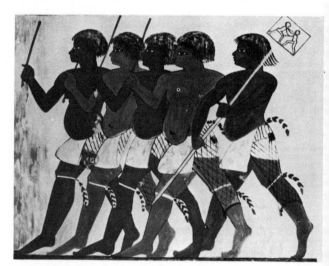

▲ Minoan fresco from Knossos.

Pompeii (around 50 B.C.) with their superbly balanced figures against rich vermilion backgrounds. There are also battle scenes, or fine down-to-earth everyday scenes, often in mosaic.

Byzantine painting
(From about 400 A.D., and continuing in Greece and Russia even to the 17th century or so.)
In Western accounts of painting there still lingers on the notion that there is such a thing as progression in art, and that it is linked to increasing realism. Byzantine painting does not aim at increased realism, but at the radiation of religious experience. A Byzantine icon is not just an illustration to the Bible, the word "icon" itself suggests more than that. Byzantine painting, both in fresco, mosaic and in the comparatively small form of icon, is often of very great beauty of colour, texture, and rhythmic and subtle drawing and patterning.

It has a sense of majesty and mystery. There will often be great affection and warmth in the representation of the Madonna and child. Gold is often used as a background, as though representing Heavenly Light, and then is also used (in a logical and structural way) as highlighting on the clothes.

As with painting originating farther East, Byzantine art uses illusion as an all-over enrichment of the painting and its subject matter, not wanting to build a deep illusion which would destroy the powerful surface of the painting. The Ravenna mosaics are one of the highpoints of Byzantine art.

Chinese painting
c. 200 B.C. to around 17th century.
The earliest surviving paintings (as with Greece, an account of sculpture would reach back much farther), already with much tradition behind them, are tomb paintings from the Han dynasty (206 B.C.–220 A.D.). From the period called "Six dynasties" (265–581 A.D.) comes the formulation of the "Six principles of painting", still of great interest today, and the artist Ku K'ai Chih (c. 344–405), who like Giotto in the West a thousand years later, painted with a new sense of vivid actuality.

The great blossoming of Chinese culture and art comes in the Tang dynasty (618–907), during which Buddhism became widely influential, and the tradition of pure landscape painting began.

The huge series of cave paintings at Tun-Huang developed in this dynasty, but work on them spread over many centuries.

The Sung dynasty (960–1279) is probably the supreme period in Chinese art. (To

mention only one great artist of the period, Fan K'uan was active 990–1030.) The importance now of the contemplative kind of Buddhism (in Japanese, "Zen") gave new depth of meaning to the painting of landscape.

More great painting came in the Yüan dynasty (1260–1368) and the early Ming (1368–1644) but in the later centuries there is a falling-off in intensity and beauty.

Japan
Japan has a long tradition of painting, with the influence of China, and therefore of Buddhism, a powerful factor in its development, such as in the Buddhist paintings of the Heian and Kamakura periods (11–14th centuries).

The term Yamato-e refers to styles of painting more purely Japanese.

Ink painting of the 14th and 15th centuries shows influence from the Sung and Ming painters, and this period includes one of the most famous of the great Japanese

▼ Mosaic from Hosios Loukos, 12th century.

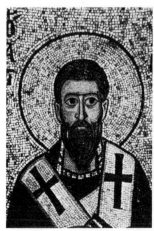

artists, Sesshū (1420–1506). In the Monoyama period (1573–1615) came the paintings—often fan-shaped—of Tawaraya Sotatsu (early 17th century). One of the great painters of decorative screens was Ogata Korin (1658–1716).

This is also the time of the beginning of the Ukiyo-e school of painting which, wishing to reach the ordinary people and consequently needing to produce work rapidly, developed the art of the wood-cut. The great artists in this tradition are notably Harunobu (1725–1770), Utamaro (1753–1806), Hokusai (1760–1849), and Hiroshige (1797–1858), and it was these and similar artists who influenced western artists at the end of the 19th century.

Arabic, Persian, Turkish, and Indian painting

Western books on painting often do less than justice to schools of painting that are not represented in the European National Galleries. Also, the idea is propagated sometimes that Islamic painting could not be realistic because of religious reasons. On the contrary, Turkish painting, for example, has not merely beautiful decorative qualities, it can be exactly descriptive and even matter-of-fact. One example of this are the scenes of Norsemen depicted in the "Album of the Conqueror" probably by Muhammed Siyah Qalam (second half of the 15th century).

Persian painting is sometimes said to be more romantic and lyrical, but realism exists there too when it is wanted. One of the greatest artists in Iran, belonging to the Tabriz school, was Mir Sayyid Ali. When the Mughal emperor Humayun visited Tabriz in 1544, he was so impressed by

this artist that he took him back to India where he was influential in the starting of the Mughal period. Paintings by Mir Sayyid Ali were amazingly beautiful, and also very realistic.

The first great Indian paintings left to us are those of the Ajanta caves, around 500 A.D. Of the later periods, the Mughal is probably the finest. Indian painting has great richness and sensuality, vivid figures and atmosphere. Later, in the 19th century, Western influences on Indian art were degenerate.

Gothic art

Europe to c. 1300 A.D. Gothic art includes, besides marvellous architecture and sculpture which lie outside the scope of this book, the greatest period of stained glass, an art which has the unusual characteristic of having begun at its peak and then declined. The glass at Augsburg and Chartres, for example, is not equalled by glass of later periods.

Gothic art also includes manuscript painting. To mention one great example among many, the Utrecht Psalter, probably made in France around 800 A.D., includes magnificent illustrations to the psalms. This is of the style called Carolingian, and was modelled on Byzantine art but transformed by an individual, and unknown, genius. The style called International Gothic, for all its Byzantine or Eastern affinities, leads towards the Renaissance. Its rich patterning and expressive rhythmic shapes gradually exhibiting a fuller sense of space and solid forms. A painting that may be mentioned here to illustrate an important point is the Avignon Pieta,

painted by an unknown master, probably French, about 1470. This large, sombre vision of the dead Christ is one of the supreme masterpieces of painting. It comes later than the Renaissance developments in Italy, and its artist was obviously aware of them, yet has used the gold background and monumental patterning of the older styles. We should beware of thinking that the "advanced" style of any period always produces the finest work.

Russian art, to the 18th century

Russia became Christian at the end of the 10th century, and many churches were soon built at Kiev and then at other cities such as Novgorod. Murals were painted, but the religious panels called "icons" became most numerous and the great artists in Russia were essentially icon-painters. There was a strong Greek influence even before the Mongol domination of Russia in 1242. Novgorod remained outside the Mongols' domination, and it was here, around 1370, that a great artist from Greece settled, who had a great influence, Theophanes the Greek. From the Monastery of the Trinity at Zagorsk came one of the greatest artists of Russia—or indeed of the world—Andrei Rublev, who was possibly born in 1360, and died in 1427. The tradition of icon-painting continued strongly until the early 18th century.

The beginnings of the Renaissance in Italy

The first great artist in the painting of our age in the West is Giotto di Bondone (1266?–1337) who painted with a new sense of actual happenings in an illusion of real space. To us his figures may at first seem

stiff and restrained, but as we get in tune with them we shall find them profoundly real as well as beautifully serene.

Giotto worked in Florence, and it was in Florence, nearly a century later, that artists appeared who would carry Giotto's realism further: Fra Angelico (1387–1455) the radiant colourist, and the monumentally realistic Masaccio (1401–1428).

Developments elsewhere in Italy often kept closer to the older attitudes, using fluid and expressive shapes and rich patterning, developing spatial effects but not necessarily valuing them highly. Simone Martini (c. 1284-1344) and Duccio di Buoninsegna beginning of the 14th century) are among the greatest artists from Siena.

The High Renaissance

The great period of Florentine painting includes an astonishing array of artists. Piero della Francesca (1416?– 492) was one of the supreme constructors of paintings, using his personal concern with mathematics. Sandro Botticelli 1446–1510) used graceful distortions akin to those of Sienese painting, in superbly lyrical and fluently constructed works, including the legendary Birth of Venus". Leonardo da Vinci (1452–1519) had an extraordinarily questing and experimental mind, yet in the few paintings that remain to us he repeats again and again the face that comes in the "Mona Lisa". Michelangelo Buonarotti 1475–1564) was an artist of breathtaking abilities. One of the supreme sculptors, and reckoned a great Italian poet, his frescoes in the Sistine Chapel in Rome are possibly the most impressive single work in all painting. Raphael Sanzio, (1483-1520) was

an artist who painted serene Madonnas, and beautifully thought-out frescoes, which combined something of the scale of Michelangelo with the subtlety of Leonardo.

The Venetian school of this period developed rich colouring and atmosphere, more overtly painterly and more sensual than the Florentine. Three artists' lives interlock: Giovanni Bellini (1431?–1516) a marvellous artist who in his long life developed great mastery and freedom, and his two most famous pupils. Giorgione (1478-1510), whose great subtlety of mood and atmosphere influenced his teacher Bellini as well as his contemporaries; and Titian (1488/90–1576) who was one of the very greatest sensual and dynamic painters, and whose work was much copied by later artists.

Tintoretto (1518–1594) is a later Venetian painter, an amazingly extreme and large-scale artist whose violent use of shadow paved the way for Rembrandt, and whose deliberate use of distortion helped El Greco.

Domenikos Theotokopoulos (1541–1614) was a Greek who studied in Italy, then settled in Spain, being known as El Greco (the Greek). It could be said that Byzantine influences were working in him, and certainly his powerful and ecstatic religious visions go far beyond any question of realism.

Michelangelo da Caravaggio (1573–1610) in a turbulent and not very long life produced paintings in which chiaroscuro became a new force. They are dramatic paintings, and in his own life Caravaggio set a new standard of artistic independence.

▲ Detail from the Wilton Diptych, 15th century.

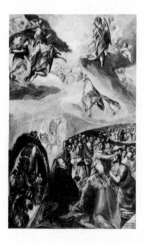

▲ El Greco: "The Adoration of the Name of Jesus".

Elsewhere in Europe up to the 17th century

Outside Italy there were great national schools of painting in which visionary religious beauty might be developed (Stefan Lochner, 1410?–1451), or calm and serene organisation (Jean Fouquet, 1420?–1480?), or detailed and sumptuously textured realism (Jan van Eyck, 1390?–1441). With Hieronymus Bosch (died 1516) we come to an astonishing original; the grotesque fears and imaginings of a whole era burst out into painting.

The later Flemish painter Pieter Breughel the Elder (1525/30–1569) owed much to Bosch, was certainly a

◀ "Courtyard of a House in Delft" by de Hooch (1629?–1684?).

moralist, but was more of a realist, depicting peasant life, and developing landscape much farther.

In Germany the expressive distortions of Grünewald (died 1528) have affinities with Bosch though their feeling is very different. Dürer (1471–1528) was a great realist who produced marvellous detailed drawings and wood-cuts as well as paintings. Holbein (1497–1543) was another great realist, who produced a magnificent series of portrait drawings.

The 17th century

During the 17th century realism reached tremendous heights in portraiture, in the depiction of everyday scenes, and in atmospheric landscapes, but there are also great examples of complex pictorial

construction and of extreme Baroque exuberance.

The Flemish artist Peter-Paul Rubens (1577–1640) produced portraits, nudes, and landscapes, in which his prodigious draughtsmanship and delicacy in handling of colour and translucent shadows, set new standards in atmospheric painting. He was influenced by the Venetian artists and in turn influenced painters as far in the future as Delacroix and Constable. He is also extraordinary for his imaginative compositions, often huge, but it is in *some* of these that the use of apprentices and assistants is responsible for less intense results.

In Holland, among many fine painters of everyday indoor scenes, Pieter de Hooch (1629?–1684?) stands out, and above all, Jan Vermeer (1632–1675), whose radiant, solid, beautifully constructed visions of ordinary life form one of the peaks of the world's painting. There was also a fine Dutch landscape tradition, including Ruisdael (1628?–1682), Jan van Goyen (1596–1656), and Albert Cuyp (1620–1691). Rembrandt van Rijn (1606-1669) has been described at length in the text. Frans Hals (1580/5–1666) was also a great painter of portraits and group portraits, with a deceptively casual mastery of oil paint and vibrancy of handling which was to influence Courbet, Manet, Van Gogh and other later artists.

In Spain there was a great realist of a different kind, Diego Velazquez (1599–1660) whose work is sombre and restrained, of a calm mastery which in the later composition has many layers of significance.

In France Nicolas Poussin (1593/4–1665) used classical and Renaissance ideas and

myths, combined with a superb and unobtrusive sense of design, and great control of atmospheric landscape. Claude Lorrain (1600-1682) concentrated on light bathing the degrees of distance in a landscape. In France Antoine Watteau (1684–1721) painted small pictures of the artificial-seeming world of Harlequin and Columbine. His paintings have delicious skill and delicacy, and an underlying seriousness and melancholy.

The 18th century
In the 18th century there were artists who continued the Rococo manner of Watteau—including his beautiful sense of landscape. Fragonard (1732–1806) is one example, as is Thomas Gainsborough (1727–1788).

Chardin (1699–1779), however, was a modest painter of still-life and everyday scenes, and Hogarth (1697–1764) a realist and social commentator.

As the century developed, other forces became evident: David (1748–1825), the French classicist, and Goya (1746–1828) the fierce and terrible Spanish artist, maker of the series of etchings "The Disasters of War", and painter of fine and often sardonic portraits and imaginative scenes.

Influential painters in England, at this time, included the visionary and socially conscious poet and painter William Blake (1757–1827), the superb animal and landscape painter George Stubbs (1724–1806), and the landscape painters, especially John Constable (1776–1837) and Turner (1775–1851).

The first half of the 19th century
Early in the 19th century we find in France huge paintings being made which for all their classical subject matter, have the boldness, the extreme emphasis on imagination and selfconscious experiment, that are characteristic of Romanticism.

We find huge scenes from mythology by David, and enormous, polished imaginings by Ingres (1780-1867), who was also capable of marvellous intensity in portraits and nudes.

Delacroix (1798–1863) looks back to the exuberance and richness of Rubens and yet his use of pure touches of colour was to influence Cézanne and Van Gogh.

In the middle of the century came great French painters of a different kind; the heroic, vigorous realist Courbet (1819–1877); the serious and solid Millet (1814–1875), the cartoonist whose small paintings with a massive realism became increasingly admired, Daumier (1808–1879); and Corot (1796–1875) with a wonderfully atmospheric and restrained vision.

In England, after the death of Turner it is doubtful whether there is much great painting. The Pre-Raphaelites attempted an interesting re-thinking of painting based on early Italian art, but their success was very mixed.

Impressionism
The modern age begins with Impressionism and Symbolism in painting as in the other arts, and these terms are not easily to be defined.

Impressionism in painting involved much direct painting from the subject, especially landscape, and much concentration on effects of sunlight. But there was nothing

▶ Poussin: "Landscape with a Snake". (detail).

new in that. The originality of these artists lies in their extreme use of broken touches of pure colour which to some degree seem to fuse together from a distance, and therefore suggests colours which could not be got at that strength by mixing. Manet (1832–1883) was at the centre of the movement, though he was an admirer of Hals and Goya and other older artists, and Monet (1840–1926) was the most extreme Impressionist, concentrating on light-effects even if he had to change canvasses frequently as the light changed. Pissarro (1830–1903) was a fine and sober Impressionist. Renoir (1841–1919) was too much a lover of massive and sensual forms to be typical, though he *can* be one of the purest of the Impressionists. He is an example of a very great artist who refused to be doctrinaire.

Cézanne (1839–1906) made an heroic and successful attempt to bring together the broken colours, sunlight effects and extreme effects of

The history of painting: a chart

This chart of the history of painting has two aims. Firstly it is intended to give some idea of the great periods of art, both as regards their length, and how they run alongside each other and overlap.

In the West, a new era began with the increasing realism of Giotto, and later, Fra Angelico and Masaccio. But that does not mean that artists everywhere immediately changed their styles. On the contrary, the great period of international Gothic, with its rich and comparatively flat patterning, both in Italy and the rest of Europe, continued long past Giotto.

At the same time painters in Greece and Russia were working in a Byzantine style, the Islamic and Buddhist traditions were flourishing elsewhere.

Secondly, a chart can give some idea which artists in different countries were working at the same time. The icon-painter Rublev was a contemporary of Fra Angelico; the great screen-painter Ogata Korin was a contemporary of Vermeer; the Japanese woodcut artist Hokusai was a contemporary of Turner and Delacroix.

It may be found interesting that these artists were alive at the same time, and this can best be made clear in a chart.

Key historical events and the rise of religions are shown in italics.

The colour bands indicate when in history schools of art were at their most active.

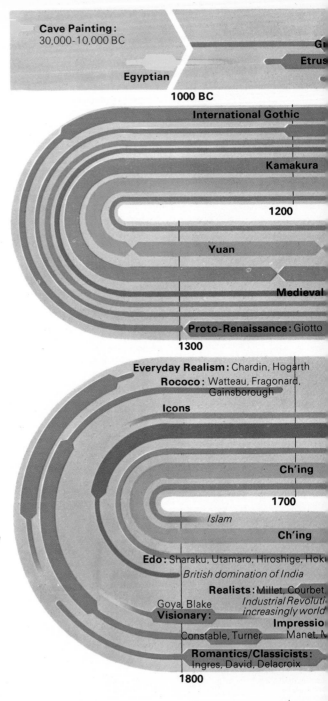

Cave Painting: 30,000-10,000 BC

Gr

Etrus

Egyptian

1000 BC

International Gothic

Kamakura

1200

Yuan

Medieval

Proto-Renaissance: Giotto

1300

Everyday Realism: Chardin, Hogarth
Rococo: Watteau, Fragonard, Gainsborough

Icons

Ch'ing

1700

Islam

Ch'ing

Edo: Sharaku, Utamaro, Hiroshige, Hoku

British domination of India

Realists: Millet, Courbet,
Industrial Revoluti
Goya, Blake *increasingly world*
Visionary:
Impressio
Constable, Turner Manet, M
Romantics/Classicists:
Ingres, David, Delacroix

1800

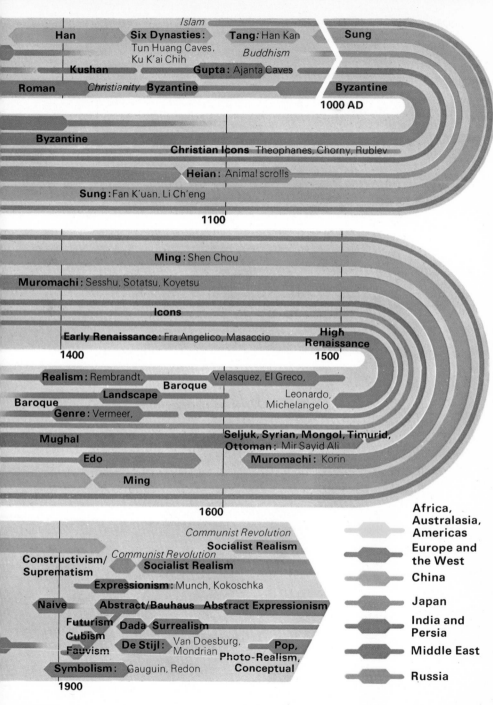

Islam

Han | **Six Dynasties:** Tun Huang Caves, Ku K'ai Chih | **Tang:** Han Kan | **Sung**

Buddhism

Kushan | **Gupta:** Ajanta Caves

Roman | *Christianity* **Byzantine** | **Byzantine**

1000 AD

Byzantine

Christian Icons Theophanes, Chorny, Rublev

Heian: Animal scrolls

Sung: Fan K'uan, Li Ch'eng

1100

Ming: Shen Chou

Muromachi: Sesshu, Sotatsu, Koyetsu

Icons

Early Renaissance: Fra Angelico, Masaccio | **High Renaissance**

1400 | **1500**

Realism: Rembrandt, | Velasquez, El Greco,

Landscape | **Baroque**

Baroque | Leonardo, Michelangelo

Genre: Vermeer,

Mughal | **Seljuk, Syrian, Mongol, Timurid, Ottoman:** Mir Sayid Ali

Edo | **Muromachi:** Korin

Ming

1600

Communist Revolution

Socialist Realism

Communist Revolution

Constructivism/ Suprematism | **Socialist Realism**

Expressionism: Munch, Kokoschka

Naive | **Abstract/Bauhaus** | **Abstract Expressionism**

Futurism | **Dada** | **Surrealism**

Cubism

Fauvism | **De Stijl:** Van Doesburg, Mondrian | **Pop, Photo-Realism, Conceptual**

Symbolism: Gauguin, Redon

1900

Africa, Australasia, Americas

Europe and the West

China

Japan

India and Persia

Middle East

Russia

Impressionism, with the classical construction of older artists such as Poussin, and determined research into the way patches of colour can build up forms and space. He is often seen as the sole forerunner of Cubism, but that is not really true.

Gauguin (1848–1903) who learned from Impressionism, belongs with the Symbolists who tried to forge symbols for natural forces, or unconscious mental processes. Van Gogh (1853–1890), for all the legends of madness that surround him, in fact made a superbly intelligent synthesis of Symbolism and Impressionism. Seurat (1859–1891) was the most remarkable of the painters using coloured dots (based on the Impressionist brush strokes) to build thought-out constructions.

The 20th century

Bonnard (1867–1947) and Vuillard (1868–1940) were superb colourists whose roots were in the 19th century and whose 20th century development is essentially a continuation, though one of marvellous freedom.

The Norwegian artist Edvard Munch (1863–1944) was probably the first of the artists called "Expressionist"—concentrating on the expression of feeling and emotion. He (and later similar artists) used distortion, but not the extreme fragmentation of forms used by other movements that began in the early 20th century.

Emil Nolde (1867–1956), Max Beckmann (1884–1950) (who in such paintings as "Departure" rivals Goya and Picasso as an anti-war artist), and Oskar Kokoschka (b. 1886) all produced vivid portraits, landscapes, and imaginative scenes.

Similar to these are the French artists who were labelled "Fauves" or wild beasts, by contemporary (1905) critics, especially the two most famous students of the artist and teacher Moreau (1826–1898). These were Georges Rouault (1871–1958),

▼ Edgar Degas: "Combing the Hair"

who became a great and violent painter of religious scenes or visions of human isolation, and Henri Matisse (1869–1954) who became one of the supreme colourists and meditators on the use of colour.

Probably the greatest modern artist was Pablo Picasso (1881-1973), who after early sombre imaginative scenes painted the explosive vision of the "Demoiselles d'Avignon", and then with Georges Braque (1882–1963) produced the sober and often classically restrained works of the various periods of Cubism, which experimented with the construction of expressive signs for the fundamental aspects of painting, including form and space. Picasso later produced the tremendous anti-war painting "Guernica" (1937), as well as a range of work unprecedented for its experimentation, and often of great beauty.

Surrealism

Surrealism is a kind of extreme version of 19th century Symbolism, given new freedom by the examples of fragmented forms in Cubism.

The two great forerunners were Chagall (b. 1887) and de Chirico (b. 1888), both with fascinating later developments. Dadaism was a post-First World War revulsion against deadness and staleness, with Max Ernst (1881–1976) inventive and stimulating and Marcel Duchamp (1887–1968) ironic and detached. Duchamp's most famous work is an extraordinary painting on glass using elaborate and obscure symbols.

Surrealism in its doctrinaire form was a deliberate attempt to shock. Salvador Dali (b. 1904) used illusions of grotesque events, Ernst and Miro (b. 1893) used paint

▲ Roy Lichtenstein (b. 1923):
"Wham!"

▲ Georges Braque:
'Mandolin".

reely to evoke "unconscious"
magery.

Paul Klee (1879–1940) had
roots in Cubism and
Surrealism, and became one of
he most complex and
profound of modern artists.

Abstract painting

Kandinsky (1866–1944),
working from the freedom of
mpressionism rather than
Cubism, and Mondrian
(1872–1944), who comes
rather from the more sober
aspects of Cubism, developed
painting which gives us
significant experiences without
the use of recognisable
magery. Both artists had an
nclination towards mysticism
and wished to transcend
everyday restrictions.

Individualists

Henri Rousseau (1844–1910)
was an amateur painter who
was also a very great artist, and
his independence of the
stylistic innovations and
selfconsciousness of much
modern art has exerted a great
nfluence.

Utrillo (1883–1955), with
his views of Paris, and

Modigliani (1884–1920), with
his "formalised" nudes and
portraits, were fine individual
artists.

Léger (1881–1955) after a
Cubist period became a painter
of massive simplicity, painting
workers of all kinds.

Socialist painting

It must not be forgotten that
this account of modern
painting refers to the West. In
the Communist countries of
the East it seems that painting
must be, and be seen to be, in
the service of the Revolution,
rather than geared to stylistic
or personal development of an
innovating kind. This is an
attitude easily dismissed by
observers in the West—
perhaps too easily. The
question posed to artists and
writers by Mao Tse-Tung at
the Yenan conference on
literature and art has a
disturbing force: "Literature
and art for whom?".

In the West there is one
example of Socialism in art
which is not easy to dismiss.
This is the period of Mexican
murals; when Diego Rivera,
Siqueiros, Orozco and others

produced work of great power.

Painting around World
War II and after

Jackson Pollock (1912–56)
invented Surrealist or freely
improvised abstractions, and
became the first of the many
post-war American influential
artists. Hans Hofmann (1880–
1966) used tremendously
varied abstract forms. Willem
de Kooning (b. 1904) and
Arshile Gorky (1905–48) used
a kind of late Cubism and late
Surrealism.

Jasper Johns (b. 1930) is a
kind of Cubist and Dadaist.
Claes Oldenburg (b. 1929) is a
maker of objects that are
ghostly or enlarged versions of
the real things that surround
us. These and other artists are
putting together visions of the
world in personal ways. The
"labels"—"pop-art" and so on,
are of little or no importance
artistically.

In Europe, important artists
probably include Jean Dubuffet
(b. 1901), ecstatic explorer of
everyday bits and pieces, and
Francis Bacon (b. 1909) a,
tormented and violently
expressive painter.

Museums and galleries

The experience of seeing paintings is very different from looking at reproductions. Reproductions may be useful in many ways, and some may be very good, but they are not usually the same size as the originals, the colours are almost never exact, and they will probably have the even, glossy look resulting from the use of inks on smooth paper, and may be surrounded by a margin of white. If we are used to looking at books, originals may strike us at first as darker and rougher, but as we come to understand the paintings better we find the experience we get from originals richer and more complete.

Seeing original paintings is easy enough if you live in a large city or can visit one. Each will have galleries and museums, probably each with its own character. In London, for example, the National Gallery has a well-balanced selection of great paintings done in the West between about 1300 A.D. and 1900 A.D. For older works, or Eastern works, you have to go to the British Museum, and for modern works to the Tate Gallery. In Paris, the Louvre combines the first two of these functions and the Musée d'Art Moderne the third, with still other museums concentrating on specific periods. The Metropolitan in New York goes from earliest times to such comparatively recent artists as Jackson Pollock.

There are also private galleries, varying from rich galleries with branches in several parts of the world, to tiny galleries which live ⋅ precariously. Simply from the point of view of a person who is eager to see the best paintings, naturally the rich galleries are most useful. Sometimes they show a range of modern paintings which a public museum would be delighted to have but cannot possibly afford. That private galleries often show inferior work will not be denied, but most students and artists are very grateful to them for the chance they afford to see good paintings, including the most recent works of the great artists still alive.

In each city, exhibitions are advertised in newspapers and magazines, and such magazines as Art International, Apollo and L'Oeil have international coverage.

Having found the paintings you wish to see, there may still be problems. If the paintings are well displayed and in good condition, there are simply the problems of concentration and receptiveness. As regards concentration, it is probably best not to try to see too many paintings at one visit. As regards receptiveness, most people find that comes and goes.

Paintings are sometimes badly displayed and not always easy to see. Very often one is simply disappointed in a painting, not realising that the lighting, or framing, or unsympathetic surroundings are subtly discouraging or worrying. One's understanding of artists is usually put together from very mixed experiences of their work, even the work done solely by themselves, and if they were artists who used helpers and apprentices, or whose painting was much copied and imitated, it can be seen that works labelled with their names may be of disconcertingly various quality.

The condition of paintings may also seriously affect how we see them. The people who clean and restore paintings, though expert in the chemical processes involved, differ among themselves about the best approach to their appallingly difficult activity. Some believe in cleaning off dirt and then discoloured varnish so sparingly that the painting still looks darker than it must have looked when new. Others clean so thoroughly that they risk ruining the painting completely. A very old painting *may* have been cleaned and retouched or partly repainted many times.

What a great artist has to give may be elusive, yet is endlessly fascinating to discover. It can only really be discovered in the presence of the real painting.

Courses

The opportunities for education in the painting and general art field are varied and numerous. Painting classes are available at most adult education institutes, often during the day as well as in the evening. These classes will often consist of a general approach to painting technique, but at the larger centres further specialisation may be possible with classes in Landscape Painting and Figure Painting. Materials are often available at a reduced price through the college concerned, though a certain basic outlay will of course be necessary. In addition to practical classes institutes may often offer Art Appreciation which is particularly enhanced in areas where there are good art galleries. Teaching in institutes can vary considerably in standard, and it is certainly worthwhile to try to make contact with someone who has already been on a particular course before registering oneself. They may be discouraging. Full details of classes can be obtained from your local institute, from the local education authority, or from your local public library. In London the publication "Floodlight" lists all evening courses in the Inner London Education Authority area, and is available from newsagents and bookshops.

VOCATIONAL COURSES

The availability of vocational courses in art is likewise considerable. It is possible to take GCE examinations at either level in Art. These courses cover the practical and historical aspects, and can usually be studied at centres of further education. At a more advanced level there is a huge range of courses on all aspects of art and painting leading to diplomas, certificates, and degrees of various sorts. All these courses require a considerable time commitment, although many of them are available on a part-time basis. Although many colleges run their own "shops" selling materials at a discount price, this has been abandoned in many places owing to the high outlay of bulk purchasing. Material costs are therefore likely to be high, and although many full-time students may receive grant assistance, this rarely provides an adequate allowance for materials. Entrance qualifications vary according to the level of study. However, in art education there is slightly less concern over educational qualifications than one would find in other subjects. Adequate examples of an applicant's ability and promise will not usually act as a substitute for the necessary "O" or "A" level passes, but may well help. However, at the highest level, the highest standard would be expected in practical work and educational achievement.

Applications for degree courses at universities are channelled through the Universities Central Council on Admissions (UCCA), whose handbook lists all available courses. Interested students should write direct to university departments for a prospectus. The address of UCCA is:
PO Box 28,
Cheltenham,
Gloucestershire,
GL50 1HY.
0242-59091

To find out about all non-university courses, contact should be made with the relevant Regional Advisory Council for Further Education. These councils hold lists of all courses in Polytechnics and Technical Colleges in their areas, together with the actual qualifications offered. Again individual colleges should be approached for details of the course(s) they offer. These lists can be purchased from the advisory councils listed below, for brevity only telephone numbers are given.

London and Home Counties:
01-308-0027

East Anglia (Norwich):
0603-611122 Ex 5072

East Midlands (Nottingham):
0602-293291

Northern (Newcastle):
0632-81-3212

North Western (Manchester):
061-236-5357

Southern (Reading):
0734-52120

South Western (Taunton):
0823-85491

West Midlands (Birmingham):
021-235-2628

Yorkshire and Humberside (Leeds):
0532-40751

Wales (Cardiff):
0222-561231

Book list

The following list aims to give an idea of the range of books available, from simple introductions which will give the beginner further ideas, to serious art books for the more advanced student. Books of reproductions vary considerably in price and an idea is also given of the range and quality available.

Books will often be found in public libraries and any good bookshop with an art department. Suppliers of art materials will also usually stock a small selection of practical painting books.

PRACTICAL BOOKS:

Beginner's Book of Oil Painting, A. Hill, Blandford, 1963, £0.90.

Beginner's Book of Water-colour Painting, A. Hill, Blandford, 1963, £0.70.

Winsor & Newton also publish introductory books of this nature for around £0.30.

Materials and Methods of Painting, Lamb, Oxford University Press, 1970, £1.10.

Walter Foster series of large format books on a large range of painting topics, published in the USA but available from art material suppliers at around £0.70 and £1.35.

Introducing Watercolour Painting, Pope, Batsford, 1973, £2.75.

Oil Painting Step-by-step, Gupthill, Pitman, 1966, £4.50.

Artist's Handbook of Materials and Techniques, Mayer, Faber, 1972, £10.00.

Materials of the Artist, M. Doerner, Hart-Davis, 1969, £3.50.

Complete Guide to Water-colour Painting, E. A. Whitney, Pitman, 1975, £6.00.

Complete Guide to Portrait Painting, Finck, Pitman, 1975, £6.00.

Penguin Dictionary of Art and Artists, P. and A. Murray, Penguin Books, 1969, £1.00.

Documentary History of Art, Anchor Books (Doubleday), USA published but generally available, 3 vols. £1.30 each.

Thames & Hudson History of Art, 1962, £9.50.

The Story of Art, Gombrich, Phaidon, 1972, £3.95.

Larousse Encyclopaedias, £2.95: **Modern Art,** 1969; **Byzantine and Mediaeval Art,** 1969; **Renaissance and Baroque Art,** 1974.

Reproductions:

Thames & Hudson World of Art Library, lengthy list of titles for around £2.00, many reproductions in colour, medium-sized format, good explanatory text.

Thames & Hudson publish many other series of reproductions, e.g. the Great Impressionists Series, large format at around £3.00. Other publishers with series of this sort are **Phaidon, Skira** and **Uffici Press**; prices are reasonable for the standard of reproduction and the amount of colour. There are much more expensive books of a correspondingly higher standard.

Two series of reproduction books which are excellent value and have a large amount of colour work are: **Dolphin Art Books** from Thames & Hudson at under £1.00, and Methuen's **Little Library of Art** at £0.25.

In all the above-mentioned series each book usually deals with a specific artist or with a "school" of painting.

ADVANCED BOOKS:

Painting in the 20th Century, W. Haftmann, Lund Humphries, 1965, 2 vols. £2.40 and £1.87.
Very good general book on modern painting.

On Not Being Able to Paint, M. Milner, Heinemann, 1971, £0.90.
The author, expert in psychology but amateur in painting, describes brilliantly her feelings and experiences as she begins to experiment with painting.

The Nude, K. Clark, Penguin Books, 1970, £1.00.
One of the most valuable books on painting, doing full justice to the many-sidedness of art yet always clear and lucid.

The Letters of Vincent Van Gogh, Ed. M. Roskill, Fontana, £0.80.
Readable and enthralling, one of the most moving and unforgettable books in the field of painting and painters, and of great interest in technical matters and the observation of colour.

Art and Illusion, Gombrich, Phaidon, 1972, £6.50.
A fascinating and influential book on a strictly limited subject. It is not about the value and greatness of art, but about ways of representing the visible world.

Meditations on a Hobby Horse and Other Essays on the Theory of Art, Gombrich, Phaidon, 1973, £2.50.

Norm and Form: Studies in the Art of the Renaissance, Gombrich, Phaidon, 1971, £2.75.
Two groups of essays, some perhaps rather specialised, but including, for example (in Norm and Form") the fascinating essay on Leonardo da Vinci's method of drawing.

Voices of Silence, A. Malraux, Paladin, 1974, £1.90.
A long and fascinating book, which can be picked up again and again even if in a casual way. Full of insight into painting, not only in a general way but on such topics as naïve art, forgeries, the value of reproductions, etc.

Meaning of Art, H. Read, Faber, 1972, £0.95.

Paul Klee on Modern Art, Klee, Faber, 1948, £0.70.
Charmingly simple yet profound. The text of a lecture given by Paul Klee in 1924.

Landscape into Art, K. Clark, J. Murray, 1976 £3.75.

Renoir My Father, Jean Renoir, Collins, 1962, £1.80.
A very readable and entertaining account by the film-director, of the great painter who was his father.

Suppliers

Art materials are not cheap and anyone taking up painting must be prepared to spend a few pounds. While there are ways of saving money, one can for example improvise a palette. But good quality materials are by many people's standards, expensive. Branches of the major specialists in art materials, namely Reeves, Rowneys, and Winsor & Newton, provide the most comprehensive range, and other art shops will usually stock their products. If in any doubt as to where to go contact the head office—addresses below:

Reeves & Sons Ltd.,
13 Charing Cross Road,
London WC2.
01-930-9940

Rowneys & Co. Ltd.,
12 Percy Street,
London W1.
01-636-8241

Winsor & Newton Ltd.,
51 Rathbone Place,
London W1.
01-636-4231

Reeves also own **Crafts Unlimited** which have Art and Craft Centres stocking materials. **Boots** and **W. H. Smith** often supply simple needs, as do many stationery shops, but for proper selection it is best to find a specialist supplier.
Some colleges and evening institutes have bulk orders for materials and pass the corresponding price savings on to students, but such systems have the limitation of a small range.

Glossary

Acrylic: normally used by artists nowadays to describe the artist's quality of the synthetic paint called acrylic polymer emulsion.
Alla prima: using a single layer of paint to reach the desired effect, not building up to it with several layers.
Altarpiece: painting (or relief carving, etc.), often in many parts framed together, on a wall behind an altar.
Assemblage: artwork put together from already existing objects which are transformed by being brought together.
Baroque: exuberant and often extravagant style occurring in 17th and 18th centuries.
Binder or **Binding medium:** a substance which dries to form a hard film, therefore the essential ingredient of paint which binds together the particles of pigment and sticks them to the "ground", or priming.
Bristle: brush. Stiff-haired brush, often hogbristles, useful for handling stiff, thick paint.
Canvas: the word is used in three ways. (1) To denote the material, usually artists' linen, commonly used for oil-painting. (Other materials such as cotton "duck" are often used for cheapness.) (2) To denote a stretched, primed piece of canvas ready for use. (3) To denote a finished painting.
Cardboard: a possible support for painting, though if oil is to be used the cardboard would usually be sized or primed or both, as canvas or paper would be.
Charcoal: useful for preliminary drawing on canvas as it can be dusted off leaving

91

a faint outline which will not discolour the paint. Also good for vigorous drawing on paper.

Chiaroscuro: the dramatic use of strong tonal contrasts, i.e., contrast of light and dark areas.

Classical: adhering to the restrained style of Greek and Roman art. Not lacking passion, but concerned with proportion and order above all.

Collage: building a painting by sticking paper, or other materials, onto a flat surface, possibly in conjunction with drawing or painting mediums.

Complementary: colours which are direct opposites on the colour-circle.

Copal: resin used both in mediums to mix with oil paint and as the main ingredient in a final varnish. Not recommended by some experts because it darkens and grows brittle with age.

Covering power: the extent of the area over which a particular paint will satisfactorily spread. Sometimes used instead of "hiding power", i.e., the opacity of a paint and therefore the degree to which it will hide whatever is underneath it.

Damar: resin used both in mediums to mix with oil paint and as the main ingredient in a final varnish. Highly recommended by experts.

Diptych: painting in two parts, whether or not framed or hinged together.

Distemper: water-miscible paint bound with simple binder such as glue size. For decorative purposes rather than artist's use. (Mayer warns against confusion with French "détrempe", which can mean either distemper or tempera).

"Earth" colours: colours got from natural minerals.

Easel painting: painting which is separate and portable, even if large (as against a mural painting, or illustration in a book), and artistically intense (as against an inn-sign or portable advertisement).

Egg: egg is a natural emulsion, i.e., it has watery and oily constituents, and in painting it is a natural "binding medium". Egg tempera is one of the oldest and most beautiful of painting mediums. In its purest form it is simply egg yolk plus water ground with pigment.

Emulsion: the most often used of egg-oil mixture (or similar, as "casein-damar", etc.). This balancing of two dissimilar ingredients is not recommended to a beginner unless he or she has a taste for experiment, as its advantages do not seem to be clear enough.

Encaustic: the use of hot wax as a painting medium. Used in ancient Greece and Egypt, but still a possible, and excellent, medium; though unusual. (Not to be confused with the use in oil paint of wax dissolved in turpentine as a medium. That is an acceptable thing to do, but it is not "encaustic".)

Filbert: for "filbert"-shaped brush.

Fixative: a liquid sprayed onto pastels, charcoal drawings, etc., to bind the layer of particles so that the work will not smudge.

"Found object": an object found casually then transformed into an art-work by changing its context into an art context and thereby focussing our attention on it and changing its significance.

Fresco: a painting medium in which pigment is applied to plaster which is not dry, so that as the plaster sets it binds the pigment onto the wall.

Gesso: a thick priming, commonly made nowadays from whiting and glue size, coated in many thin layers onto a panel of wood or hardboard to form a painting surface for tempera or (with additional sizing) for oil. It has the advantage over oil painting that it does not yellow with age, but it is too brittle for application to canvas.

Gouache: water-colour which has been made opaque by the use of additives.

Ground: the surface on which the paint is applied.

Gum Arabic: gum used as a binder for water-colour.

Hardboard: excellent support for painting.

Hiding power: see Covering power.

Icon: a painting having urgent religious significance, typically a comparatively small panel. Not just a religious illustration.

Impasto: thick touches or heavy layers of paint, usually oil paint, and projecting somewhat from the ground.

Liner: brush with long thin hairs for linework.

Linseed oil: a drying oil made from the seeds of the flax plant. Commonly used in oil painting in several forms. Stand oil is made from it, a thick oil which yellows less with age.

Mahlstick: stick held across the painting but not touching the wet paint, to rest the hand on while doing delicate work.

Medium: can be used to denote the liquid with which the paint is made, or modified; or the kind of activity the artist does, as, oil painting, fresco, etc.

Muller: a heavy glass tool for grinding pigments.

Mural: a painting on a wall. Not necessarily a fresco—any kind of painting on a wall.

Paint quality: the good use of the medium. Not whether the painting is good or bad, but whether the paint is used to advantage.

Palette: the board, glass, etc., on which the artist sets out and mixes his colours. Also, the range of colours he uses.

Pastel: pigment made into sticks with a minimum of gum.

Pentimento: a part of a painting which was altered by overpainting, but which has again become visible because the overpainting has become more transparent with age.

Pigment: not paint, but the basic inert colouring matter used in making the paint.

Polyptych: painting made of several parts, presumably more than two (diptych) or three (triptych).

Poppy oil: made from seeds of poppy. A drying oil still used by artists and in the manufacture of some paints. Less common than linseed partly because it dries slowly.

Primary colours: in painting, red, yellow and blue.

Priming: the coating which prepares a surface to take the paint.

"Ready-made": term used by Marcel Duchamp to describe an art-work which was an ordinary object but which has been changed by transferring it into an "art" setting and therefore making us see it differently.

Retouching varnish: similar to picture varnish but designed to be used for bringing up the rich, oily appearance of a paint film as a preliminary to painting further on it.

Rococo: highly ornamented 18th century style full of artifice, and in painting also full of awareness of nuances of emotion and atmosphere.

Romantic: a style found in the late 18th and 19th centuries that is often grand, picturesque, passionate. Concerned with formal structures but usually an irregular form resulting from the urgency of the subject matter, rather than beginning with notions of symmetry or measured proportions.

Sable: expensive but excellent kind of soft-haired brush.

Scumble: the dragging, half-opaque application of paint. Not a filmy glaze, but with a strong sense of the physical presence of the paint. This gives a broken layer, so that something of an underneath layer shows through.

Secondary colours: mixtures of two of the primary colours, therefore green, orange and violet.

Sfumato: delicate use of faint shadows and ambiguities, as in Leonardo's "Mona Lisa".

Size: liquid brushed on a surface to make it less absorbent. In painting, most commonly used is glue size, made from hide such as rabbit skin. It is important that it should *not* be used as a layer of any thickness or glassiness.

Stretcher: wooden frame, slotted but not fixed at the corners, on which canvas may be stretched. The joints may be driven slightly apart by wedges and the canvas tightened if it has slackened because of atmospheric changes.

Support: the panel, hardboard, canvas, etc., on which the ground and then the painting are built.

Tempera: originally used in connection with whatever the pigment was "tempered" (i.e., bound) with, as "oil tempera", etc. Now normally used of egg or emulsion techniques—egg, egg-oil, casein, etc.

Tessera: small flattish square of stone, ceramic, etc., used in mosaic.

Tone: the degree of lightness or darkness of a colour, or of a patch of charcoal, pencil, etc.

Tooth: the roughness of a canvas or other surface to be painted on, which helps the paint come off the brush and adhere to the surface.

Triptych: painting in three parts, whether or not fixed together.

Underpainting: layer or layers of paint preliminary to the final layer.

Varnish: a liquid which dries to a transparent film, applied to a painting (when thoroughly dry) to protect it from dirt and pollution.

Vehicle: the liquid used to bind the pigment in a paint.

Walnut oil: drying oil from walnut kernel. Not common nowadays.

Wash: thin, broad layer of paint, especially as in water-colour with a large brush and thin watery paint.

Wax: used dissolved in turpentine as an oil painting medium, and used hot as the binding medium in the "encaustic" technique.

Index

Numbers in italics indicate
illustrations

Credits